# A–Z

## OF

# WAKEFIELD

PLACES - PEOPLE - HISTORY

Paul L. Dawson

AMBERLEY

First published 2019

Amberley Publishing
The Hill, Stroud, Gloucestershire, GL5 4EP
www.amberley-books.com

Copyright © Paul L. Dawson, 2019

The right of Paul L. Dawson to be identified as
the Author of this work has been asserted in
accordance with the Copyrights, Designs and
Patents Act 1988.

ISBN  978 1 4456 8730 8 (print)
ISBN  978 1 4456 8731 5 (ebook)

British Library Cataloguing in Publication Data.
A catalogue record for this book is available
from the British Library.

Origination by Amberley Publishing.
Printed in Great Britain.

# Contents

Introduction                                    5

Aire and Calder Navigation                     12
All Saints, Cathedral Church of                13
Almshouses                                     15
Amory, Thomas                                  16
Austin House                                   17

Bishop's Palace                                18
Briggs, Henry                                  18
Burney Tops House                              19
Bull Ring, The                                 21

Carnegie Library                               22
Catacombs                                      23
Cattle Market                                  23
Chantry Chapel                                 23
Chalmers, Revd Andrew                          24
Clarkson, Henry                                25
Church Institute, The                          26
Clayton Hospital                               27
Corn Exchange                                  28
Courthouse                                     29

Drake, Charles Henry                           30
Dickens, Charles                               31
Dykes Family                                   31

Egremont House                                 32
Empire Theatre                                 33

Fennell, Louisa                                34

Gaskell, Benjamin                              35
Gaskell, Daniel                                37
Goodchild, John Fletcher                       39
Goodwyn Barmby, Revd John                      40

Hepworth, The                                  43
Heywood, John Pemberton                        44
Holy Trinity Parish Church                     45

Indigo Dye Works                               46

Johnstone, Revd Thomas                         47

Kirkgate Railway Station                       48

Lee, John                                      49
Lumb Family                                    49

Marriott, William Thomas                       51
Market Cross                                   52
Marygate                                       53
Methodist New Connexion                        55
Milnes, James                                  56
Milnes, Mary Bridget                           57
Milnes, Richard Slater                         57
Moot Hall                                      58

Naylor House                                   59
Navigation Yard                                60

Orangery                                       61

Pemberton House                                62
Potter, John                                   63
Public Library and
    Assembly Rooms                             64

Quaker Chapel                                  65
Quebec Street Tabernacle                       66
Queen Elizabeth
    Grammar School (QEGS)                      67

Racecourse                                     68
Ridings, The                                   69
Rideal, Titus                                  69

St Austin's Roman
    Catholic Church                            70
St Andrew's Parish Church                      71
St Faith's Chapel                              71
St John's Parish Church                        72
St John's Square                               73
St John's North                                73
St Mary's Parish Church                        73

St Michael's Parish Church 74
Salt, Titus 75
Six Chimneys 75
Slavery 76
Strafford Arms Public House 77
South Parade 78

Taylor, Kate 79
Town Hall 80
Towers, The 81
Trinity Walk 81

Unitarian 82
United Methodist Free Church 83
Unity Hall 84

Vicarage, Old 85
Vincent House 85
Victoria, Statue of 86

Votes for Women 87

Wakefield and Barnsley
   Union Bank 88
Westgate Chapel 89
Westgate Railway Station 90
Westgate End Wesleyan Chapel 91
West Parade Wesleyan Chapel 91

X-ray Department 92

York House 93

Zetland Street 94
Zion Chapel 95

Bibliography and
   Further Reading 96

# Introduction

Wakefield has been a place of habitation for around 6,000 years. The first written evidence for the town comes from the Domesday Book (1086). The only tangible link we have between medieval Wakefield and the present is the layout of the streets and the cathedral, parts of which date back to the twelfth century. Over the past thousand years Wakefield has experienced a period of extensive change – perhaps none more radical than during the early years of the eighteenth century. Wakefield had been regarded as the capital of the West Riding of Yorkshire since the Middle Ages as it was one of the largest population centres in the area until the late eighteenth century. The town had been a parliamentary borough, returning its own MP to London from 1832, and became a municipal borough with a mayor from 1848.

The town was a centre for cloth dealing and at one time had two piece halls, a white cloth hall and a tammy hall. For much of the eighteenth and nineteenth centuries, Wakefield had a diverse economy. Textile mills were grouped around the River Calder, as well as close to the town centre on Westgate, and a large glassworks in the east

*Below left*: Painting by Louisa Fennell looking down Northgate to the cathedral.

*Below right*: Louisa Fennell's painting of Bread Street.

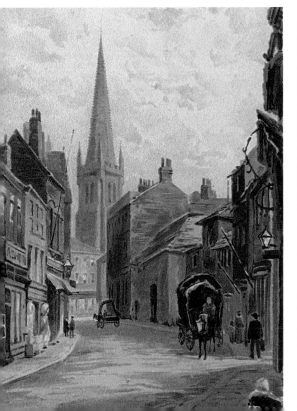
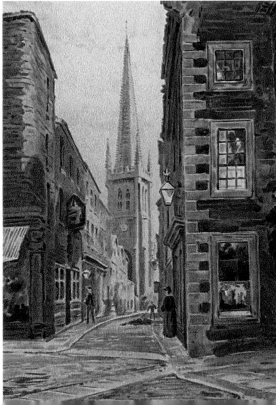

of the city was a large employer. There were several collieries around the outskirts of the town; indeed, from 1947 the National Coal Board was a major employer. The Eastmoor area was once home to large brickyards. Here, too, was heavy engineering as well as Portland cement production, malting and a thriving trade in soft drinks. E. Green & Sons factory on Calder Vale Road (before moving on to Ossett) was famous for manufacturing the 'Economiser', patented in 1845 by Edward Green. It was a device fitted to a boiler that saves energy by using the exhaust gases from the boiler to preheat the cold water used to fill it. In recent years all the coal mines and the mills (bar one) have closed, being replaced by light industrial areas and service centres for international companies.

In addition, the town was known nationally for its wool, corn and cattle markets, the latter being established in 1765. Such was the scale of the business that by 1860 the cattle market was said to be the largest in the north of England. The cattle market closed in 1960s, but its legacy lives on with the road name 'Fair Ground Road'. Such was the scale of cattle selling here that it seems any land suitable for grazing was turned over to fatten up those cows that had been walked a long distance to the market. This raised the price of the land to such a premium that it made industrial development uneconomical. In the place of mills, factories and open fields are office park developments or new housing estates, which catered for those working elsewhere like Leeds or Bradford. The city also provides jobs in the bar and leisure industry as well as the IT or service industry. Recent development has seen the new shopping

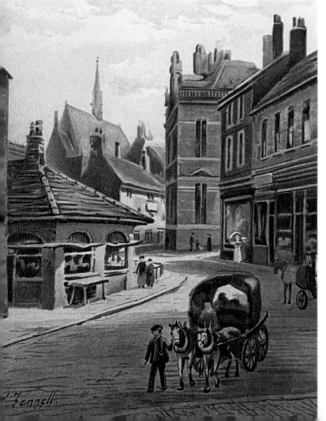

Louisa Fennell's painting of the Shambles.

mall of Trinity Walk laid out, a new urban centre at Merchant Gate betwixt Westgate and Balne Lane, as well the impressive £35 million 'The Hepworth Wakefield' (named in honour of local sculptress Barbara Hepworth) that opened in May 2011. Wakefield is known as the capital of the Rhubarb Triangle, which also comprises Morley and Rothwell, an area notable for its early forced rhubarb. In the 1870s two trains left Wakefield every day, bound for Covent Garden laden with rhubarb. In July 2005 a statue was erected to celebrate this facet of Wakefield.

Wakefield in 1880 was served by excellent transport links – water, road and rail. Transport by water came to Wakefield under an Act of Parliament dated 4 May 1699. The Aire and Calder Navigation was then constructed, making the River Calder navigable; it opened to Wakefield from 1702 and boosted the town's economy greatly. The water transport links expanded throughout the eighteenth and early nineteenth centuries, linking Wakefield with other centres of production and the ports of Goole, Grimsby and Hull.

From 1741 Wakefield was linked to the then expanding turnpike network. The improved roads allowed quicker journey times and witnessed the expansion of stagecoaches, linking Wakefield with the wider world far quicker than ever before. Allied to the development of the stagecoach and improved roads was the introduction of horse buses in the second half of the nineteenth century. The double-deck and single-deck horse-drawn bus and the hackney cab services provided quick and cheap transport in an era before more modern public transport. Private transport developed from the turn of the nineteenth century – the horse trams and buses gave way to the electric tram, motor bus and motor car. Such was the pressure on the roads of Wakefield from the motor car, that many roads were widened and an inner-city bypass, Marsh Way, was built. In more recent years the city centre has been largely pedestrianised, along upper Kirkgate and Westgate to increase footfall to the shopping precinct here and the Ridings Shopping Mall. The 1950s linked Wakefield to the then new and expanding network of motorways.

From 1840 Wakefield was linked to the then developing railway with the opening of Kirkgate station on 5 October 1840. In 1857, the line from Wakefield to Leeds was opened, and Westgate station was opened in 1867. Allied to the development of the railway was the tram network. Although a number of tramway schemes had been proposed for Wakefield from the 1870s onwards, an electric tram system was introduced in the area from August 1904 by the Wakefield & District Light Railway that took over from the horse-drawn bus service. It helped people from the growing suburbs as well as connecting what is now known as the 'Five Towns' to get into and out of the city centre. The trams ran until 1932 when motorised buses became the main means of public transport.

The population of Wakefield grew by just over 50 per cent between 1801 and 1850, and manifested itself with extensive and unrestricted building of small houses on every available piece of land, including along the edges of yards dating back to the medieval origins of the town. To cater for the population boom new streets were laid out and houses built between Northgate and Stanley Road – Saville Street and York Street being examples. This area was gradually infilled, the new working-class

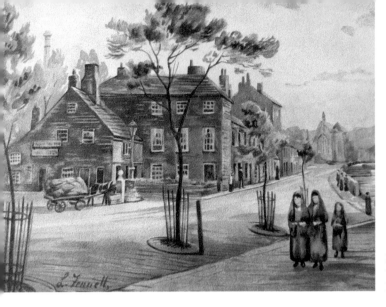

Looking down Westgate to St Michael's Church, by Louisa Fennell.

housing contrasting starkly with the early Victorian middle-class houses on College Grove Road. Large Victorian villas were also developed all around Westfield. Other alterations occurred off Westgate, and New Scarborough and New Brighton were laid out at this time, as was Belle Vue and Primrose Hill.

In the years immediately after the First World War new council housing schemes were constructed, the first being at Portobello in Belle Vue, which was constructed from 1921 to replace the cramped and often overcrowded inner-city housing stock. New council estates were built in Lupset (from 1924), Eastmoor and Darnley (from 1930), and at Flanshaw and Peacock (from 1936). Lupset estate was expanded in the 1960s with the building of houses at Snape Thorpe.

In addition to the provision for new working-class homes, a new 'Garden City' housing scheme was developed between Dewsbury and Alverthorpe Road for the more affluent members of the working classes. Ribbon development also occurred in the 1920s and 1930s along Horbury Road and Thornes Road as the city expanded and developed new suburbs.

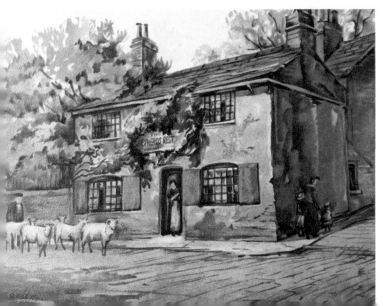

The Shepherds Rest on George Street by Louisa Fennell.

High-rise living came to Wakefield in the 1950s and 1960s – the tower blocks dotted around Wakefield dominate the skyline. Carr House was opened in 1961 and Primrose House received its first residents in October 1963. In more recent times new private housing schemes have been built both on outlying land around Wakefield or on derelict industrial sites close to the waterfront or by Westgate railway station. Mills and warehouses on the waterfront and former Methodist chapels have also been converted into private accommodation.

The administrative centre of West Riding County Council was established in Wakefield in 1889 through the Local Government Act of 1888. This came to an end in 1974 when the West Yorkshire Metropolitan County Council was formed. County Hall was built to accommodate the county council in the four years from 1894, being officially opened by Charles George Milnes Gaskell MP (notably Unitarian) on 22 February 1898. The original building was extended within a few years, with new wings being added between 1912 and 1915. The builder was George Crook of Wakefield. The council was discontinued in 1986 and the County Hall was acquired by the City of Wakefield Metropolitan District Council in December 1987 to continue the use of the building for local government purposes – as the council's main headquarters.

In 1880 medical treatment was provided for the poor people of Wakefield by charities along with an increasing number of private doctors and medical men. By the mid-twentieth century the city could boast five hospitals as well as the West Riding Lunatic Asylum, which was established in the first half of the nineteenth century – possibly earlier. The House of Recovery was founded in 1826 and was run largely by women, notably Mrs Margaret Heywood and Miss Heald, who were both active Unitarians. Clayton Hospital moved from Wood Street to Northgate between 1876 and 1879 with the construction of new buildings. The infirmary of the New Union Workhouse on Park Lodge Lane (erected in 1851) was developed as Wakefield County Hospital, becoming part of the National Health Service in 1948. After 1968, it too catered mainly for elderly patients. All the workhouse buildings have now been demolished and the site is occupied by a housing estate.

Pinderfields General Hospital originated as part of the West Riding Pauper Lunatic Asylum (established in 1818) through the efforts of Dr William Bevan Lewis in 1867 to provide separate accommodation for the recently diagnosed mentally ill. The hospital was expanded in 1899, with new buildings being opened on 8 March 1900, at a total cost of £69,000. However, outbreak of war in September 1939 designated the hospital as an emergency hospital to treat the war injured. Farmland next to the hospital was acquired and wooden huts were built to increase capacity. The psychiatric patients from the acute hospital were transferred to asylums across West Riding and did not affect Stanley Royd Asylum patients. Today a new Pinderfields General Hospital has replaced the former premises. Clayton Hospital, Pinderfields Hospital and the County Hospital in 1948 provided state-funded healthcare under the terms of the Beveridge Report. Snapethorpe Isolation Hospital was constructed was opened in 1907 and

closed in 1959. Maternity cover was provided from 1931 by Manygates Hospital, replacing an earlier maternity hospital in Blenheim Road as well as private midwives.

Education in Victorian Wakefield was provided by a number of different bodies. Charitable schools comprised the Queen Elizabeth Grammar School and the Greencoat School, which stood on Westgate next to Westgate Chapel. Ostensibly a Church of England School, the masters from the 1750s to 1830s were all Unitarians. The Established Church provided parish schools such as the Bell School and Holy Trinity Schools. The Wesleyan Methodist Church ran the Methodist Day School, which opened in 1843, while Unitarians and Congregationalists backed the Lancasterian School. Private schools also existed, one such example being the Heath Academy. Through the Education Act of 1870 the board schools on Ings Road, Westgate and Eastmoor Road were built. Attendance at school from the ages of four to twelve was made compulsory by an Act of Parliament in 1880.

As the twentieth century progressed, empowered by the 1948 Education Act, more schools were built and others moved to new buildings; for example, Thornes House School and the Cathedral School moved from the Old Grammar School on Brooke Street to new premises on Thornes Road. Wakefield College is the major provider of further education in the area, with around 3,000 full-time and 10,000 part-time students, and campuses in both the city centre and surrounding towns. The college has a sixth form, and in addition to A levels it also offers GCSE courses and a wide range of vocational qualifications.

The apparent lack of religious belief (or at least its practice) among the working class and urban poor was a constant Victorian concern. In the first half of the nineteenth century Wakefield and the surrounding area gained several new parishes, and in the town itself the following parishes were created: Holy Trinity (20 October 1844), St Mary's Primrose Hill (3 September 1844), St Andrew's on Peterson Road (3 September 1844) and St Michael's (1869). Wakefield had a strong sense of Nonconformist worship and by 1936 Wakefield as an area had over thirty Methodist chapels. The grandest of the Methodist chapels was West Parade Wesleyan Chapel, which opened in 1803. Market Street United Methodist Free Church (1857), Grove Road Methodist New Connexion Chapel (1866) and Brunswick United Methodist Free Church (also 1866) all added to the architecture of the cityscape.

The Unitarian chapel on Westgate was founded in 1661 and the current chapel was built in 1752, which replaced an earlier building of 1697. The congregation had members from the great and good of the local citizenry. Indeed, Westgate Chapel and its congregation played a leading part in the social, civic and economic development of Wakefield from 1700 to the years just before the world wars. In later decades the congregations at Zion Chapel and West Parade Chapel played a part in the town's economic and social development. In 1888, when the diocese of Wakefield was formed, the parish church became Wakefield Cathedral and the town became a city. William Walsham Howe was the first bishop.

The townsfolk have had a choice of a plethora of public houses at which to drink and a wide choice of other entertainments. Those abstaining from alcohol had the temperance bar and those interested in a cultured night out had the Theatre on

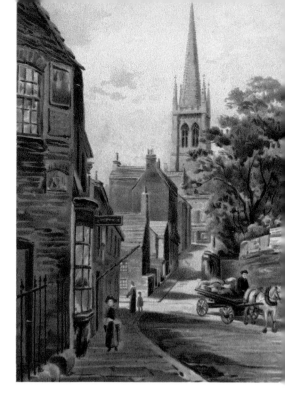

The Springs by Louisa Fennell.

Drury Lane, which was supplemented with the Empire Theatre on Kirkgate after the turn of the century. Many churches and chapels also provided their own evening activities, reading rooms and sports clubs.

The coming of the cinema in the years immediately prior to the First World War brought a cheap mass-market media and a number of inner-city cinemas were built, such as the ABC on Kirkgate, the Carlton on Grove Road as well as the Play House on Westgate. Other already existing buildings were also converted into cinemas, such as the Corn Exchange, the Empire Theatre, the Theatre Royale and the Opera House.

The Olympia Rink for roller skating was opened on 15 May 1909, standing at the junction of Ings Road and Denby Dale Road, offering a different form of recreational activity. Sun Lane Baths was opened in 1938 – a more modern facility than the baths in Almshouse Lane, which had been built in 1874. Sun Lane also had a stage for theatrical performances, but this was demolished in 2006 as part of the regeneration of the market and Marsh Way area. A new Sun Lane Leisure Centre was built in 2012.

In recent decades all of Wakefield's older cinemas have closed and many inner-city bars and clubs have closed down, along with a number of the dance halls, like the Embassy Ball Room off Market Street. Wakefield Trinity Rugby Football club moved to its current home in Belle Vue in 1879, where many hundreds of the city's residents – then and now – support their home team.

What follows is a personal and eclectic mix of people and places who contributed much to Wakefield in the past and in more recent years. I must thank my missed friend John Goodchild for providing illustrative material from his extensive collections.

Paul L. Dawson BSc Hons MA MIFS FINS

# Aire and Calder Navigation

Commenced in 1696 and opened fully by 1704, the Aire and Calder Navigation linked Wakefield to the Humber and the sea. Wakefield merchants, however, also needed a route to the cloth-producing areas of the Pennines and to channel the corn produce of the eastern counties to industrial Lancashire and Cheshire. The Calder and Hebble Navigation was complete by 1770, reaching Sowerby Bridge, and subsequently extended by canals to the north-west.

Wakefield's waterfront adjacent the river and the cut was once a hub of activity with warehouses, mills, maltings and boat-building enterprises. At the foot of Chantry Bridge Stands Navigation Yard. On the west side of Kirkgate, opposite Navigation Yard, stood the Soke Mill (also known as the Kings Mill). From the Middle Ages until the 1850s all grain in Wakefield had to be milled at the Soke Mill, which was down by Chantry Bridge until the road bridge was built in the 1930s. If it was milled elsewhere a fine had to be paid to the lord of the manor. This was one of the many rights and privileges held by the lord, who controlled the courts and the official weights and measures used in the markets since medieval times.

In 1930 Wakefield Corporation and the Aire and Calder Navigation Co. and the Ministry of Transport agreed to build a new bridge some 75 feet in width in a direct

Now overgrown, this is the earliest stretch of canal in Wakefield and dates from 1696 to 1702.

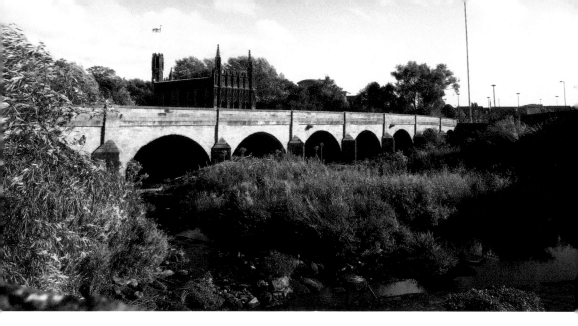

*Above*: Wakefield Bridge was built in the fourteenth century and rebuilt in the eighteenth century.

*Right*: Standing hard by Navigation Yard was the Soke Mill, which was demolished to make way for the current Wakefield Bridge in 1932.

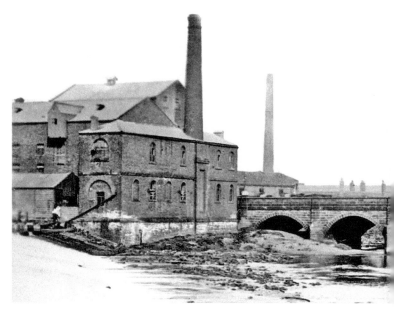

line from the bottom of Kirkgate, where the road passed under the railway, alleviating the dogleg turn to the Chantry Bridge and the bottleneck caused by the narrow bridge. The new bridge was opened on 1 June 1933 and cost £50,000 to construct.

# All Saints, Cathedral Church of

Standing in the heart of Wakefield is the city's former parish church, now Wakefield Cathedral. It was the parish church until 1888 and many believe it stands on the site of a Saxon church – a church was recorded in the Domesday Book, but we cannot be

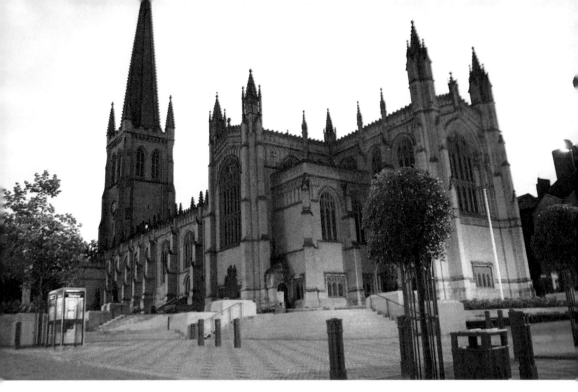

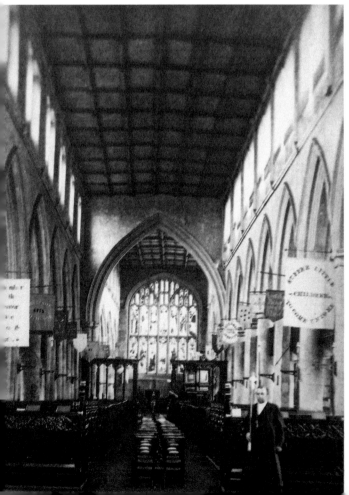

*Above*: The cathedral is a fifteenth-century building with twentieth-century additions.

*Left*: The interior of the cathedral as it was from the 1860s to the turn of the nineteenth century.

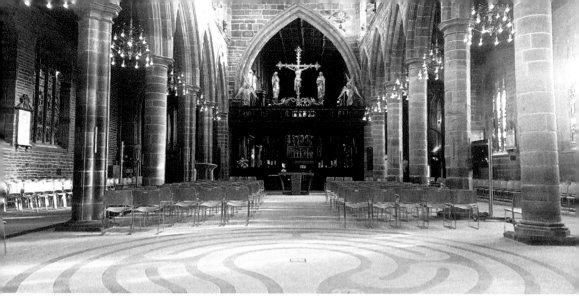

The cathedral's interior after its recent modernisation that swept away the eighteenth-century pews.

certain of its location. A Norman church was erected on the site soon after 1090, but very little of this early building remains. The oldest surviving masonry can be found above the nave arcading, which predates the collapse of the central crossing tower in the early fourteenth century that destroyed much of the early church building. During the rebuilding of the church, the chantry chapel of St John the Baptist on Northgate was enlarged and rededicated as the parish church. Nothing today remains of the medieval St John's Church; it stood somewhere in the vicinity of the Grammar School Lodge on Northgate. In 2012, the cathedral interior was stripped bare of its Victorian pews, early eighteenth-century pulpit and other older fittings that gave the interior character.

# Almshouses

Alongside the site of what had once been Holy Trinity Church Boys' School stands the Caleb Crowther Almshouses, the shells of which were built in 1838–39 for poor Nonconformists but were not fitted up until 1862–63. Under the provisions of the trust, the trustees were not to be Roman Catholic nor solicitors, and had to agree in writing that they did not intend to be a Tory or a member of the Church of England. Caleb Crowther's grave is behind the almshouses, although the gravestone has been moved. A much older set of almshouses stood on Almshouse Lane, which were established on 4 February 1646 to house ten poor men and ten poor women by Cotton Horne. The building had five rooms, with two occupants per room. A further five almshouses were erected in 1669 to accommodate ten poor men. These buildings were pulled down in 1793 and replaced by new buildings. These were closed down and on 15 May 1901 the foundation stones of new almshouses were laid on Cotton Street and Horne Street.

The almshouses on Almshouse Lane were built in 1796 to replace much older seventeenth-century buildings.

# Amory, Thomas

Thomas Amory (*c.* 1691–1788) was a writer of Irish descent, best known as the author of *The Life of John Buncle, Esq.* The work is a collection of Buncle's 'memorandums of everything worth noticing', including philosophical, mathematical and theological musings. But at a deeper level it is also a work of Unitarian theology, which seeks to persuade its reader of the importance of rational enquiry. The pioneering remainder bookseller James Lackington claimed that he had been converted from 'a poor ignorant, bigoted, superstitious Methodist' by reading the book, as it had forced him to 'reason freely on religious matters'. Later in life Thomas lived on Westgate with his son Dr Robert Amory and attended Westgate Chapel.

Langham House on Westgate is where Thomas Amory resided before his death in November 1788.

# Austin House

This landmark building on Westgate was built by Robert Lumb (1724–89). He was a leading cloth merchant involved in the production of worsted cloth and a staunch member of Westgate Chapel. In March 1763 he bought land on Westgate to build a fine mansion. With Robert's death the house was occupied by Thomas Lumb, upon whose death in 1813 he left £27,000 in property to William Jones Kendall and the Lumb family business continued as Lumb & Kendall. With the death of Thomas Lumb, Robert Lumb's Westgate mansion house (seen here) was divided into two houses, with W. J. Kendall occupying one half and Dr Disney Alexander, also a Westgate Chapel man, occupying the other. (Alexander lies buried in the chapel yard and his daughter is commemorated with a handsome tablet in the chapel.) The business continued after W. J. Kendall's death, but was wound up in 1821. The property had extensive warehouses behind as well as workshops for use by the firm. The building has suffered much in recent decades through poor planning development control by Wakefield Council. In the 1970s the ground floor was unfortunately converted into a car showroom.

Austin House was built by Robert Lumb in 1763, making it one of the oldest buildings in Wakefield. It has been greatly affected by poor planning control.

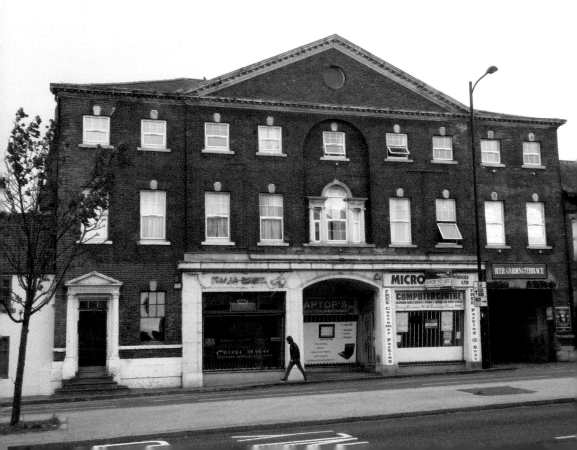

# Bishop's Palace

When Wakefield parish church was elevated to cathedral status in 1888, the new diocese needed a suitable residence for the lord bishop. No. 10 South Parade had been built by Unitarian wool spinner William Marriott in 1826, with his co-religionist and dyer Richard Burrell living at No. 11. In 1888, the large house became the first Bishop's Palace, until the purpose-built residence Bishopgarth was completed in 1896. It boasted fine stained-glass windows by Kemp of London. In 1939 the palace was sold and Woodthorpe Lodge became the bishop's new residence. Bishopgarth itself was for many years owned by West Yorkshire Police, but it was demolished to make way for new housing. No. 10 South Parade was occupied for a time by Baron Kilner, owner of the Kilner Jar manufactory and ancestor of TV personality Jeremy Clarkson.

# Briggs, Henry

Henry Briggs was the son of a Halifax banker. He became partner in a textile company and he and his business partners married the daughters of a colliery owner at Flockton. With the failure of the textile business, Briggs was invited to co-manage his wife's colliery. The concern quickly prospered and a new pit was sunk at Castleford in 1836. The year 1839 witnessed him take Charles Morton, an active Unitarian like Briggs, who in 1850 would become one of the first national mine inspectors, into the business as manager. Morton left the partnership and Briggs took his sons into the business. Workers' cottages and a school were built at Whitwood, and at Flockton a place of worship, school, reading room and other amenities were provided by the company, which were commented upon favourably by a government report of 1842. The Briggs family moved to Outwood Hall, a new pit was sunk at Methley Junction, and iron foundries and jute-spinning factories were purchased. Perhaps due to the communist influence of his minister, Rev Goodwyn Barmby, he introduced profit sharing with his workers at his companies in 1865, and a worker director was appointed to the board some years later. Henry Briggs was a well-known Unitarian lay minister in the

Monument to Henry Briggs and
his sons at Westgate Chapel.

West Riding and he struck an imposing figure, standing at 6 feet 2 inches. He died
in 1868 and has a monument erected to his memory at Westgate Chapel, where his
father and two sons are also commemorated.

# Burney Tops House

This was built in the 1740s for William Charnock, a wealthy Wakefield wool merchant
who sold textiles to the Dutch East India Company. Part of the house was demolished
to make way for West Parade Street. By 1820 the house was occupied by the wealthy
Unitarian Backshell family. George Charnock, William's younger brother, built Grove
House in the 1750s, which was demolished in January 1979. Next door to Burney Tops
House stands the manse for West Parade Chapel. Here lived the mother of Rudyard
Kipling, the wives of painters Edward Burn Jones and Edward Poynter, as well as the
mother of Stanley Baldwin MP, sometime prime minister.

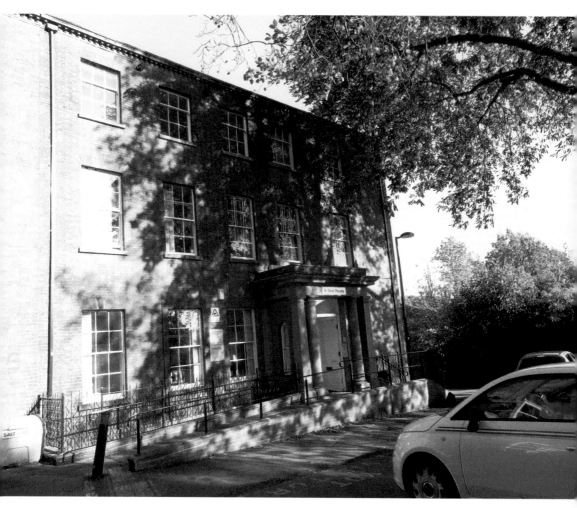

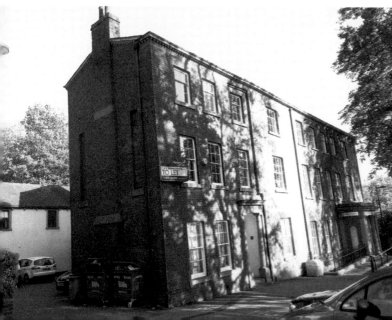

*Above*: Burney Tops House stands on West Parade and was built in the 1740s.

*Left*: The Manse stands on West Parade alongside Burney Tops House. It was built in phases from 1770 to 1871.

# Bull Ring, The

The Bull Ring at the heart of Wakefield has changed greatly since the space was opened out in the 1890s. Historically, it was known at the Market Place. The Bull Ring was the small road that connected the marketplace to Marygate.

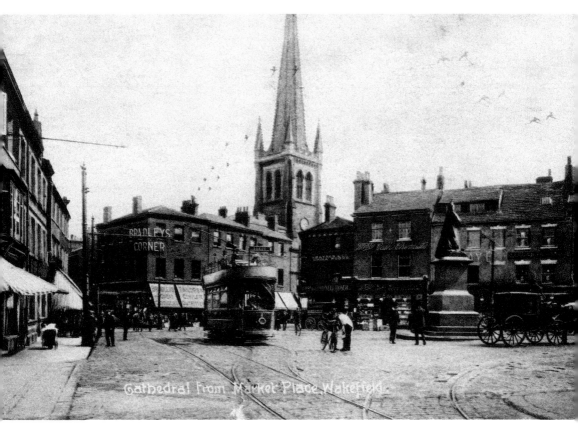

*Above*: The Bull Ring is the heart of Wakefield. We see it here *c.* 1910.

*Right*: The Bull Ring in 2018 – a totally different space to over 100 years ago.

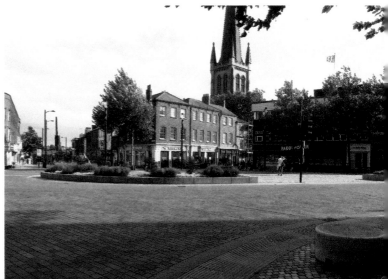

# Carnegie Library

Wakefield had a subscription library from 1786, but it was only in 1905 that a free library was built. An amount of £8,000 was secured from Andrew Carnegie, who financed libraries throughout Great Britain and America. Known as the 'Drury Lane Library', it was designed by Trimmell, Cox & Co. of Woldingham, Surrey, and built by Bagnall Brothers of Wakefield. The foundation stone was laid on 15 February 1905 by the Mayor of Wakefield, Mr Alderman Childe. Andrew Carnegie opened the library on 2 June 1906. The first librarian was Mr George Wood, who remained in the post for thirty-two years. The library was extended in 1935 and a new junior library was opened in 1939. Charles Skidmore, a local man, was the second benefactor, giving the library no fewer than 2,000 books and pamphlets about Wakefield or originating in Wakefield. The building ceased to be used as a library in 2012 when it was moved into the new Civic building, Wakefield One.

Carnegie Library on Drury Lane, now home to the Art House.

# Catacombs

Beneath Westgate Chapel we can find some of the earliest – if not *the* earliest – catacombs in the north of England for public burial. The catacombs were built in two stages: the main body in 1752 as an integral part of Westgate Chapel, and a much later extension of 1808. Burial in the catacombs was a way of funding the construction of the chapel. Catacombs once existed under St John's Parish Church, but they were cleared away by the Victorians.

# Cattle Market

Founded in the 1760s, the Wakefield Cattle Market was once the largest in the north of England. It flourished for nearly 200 years and was finally closed in the years after the Second World War. The site is now occupied by the Royal Mail sorting office.

# Chantry Chapel

It was built in the fourteenth century, sometime in and after 1342 when the timber bridge over the river was replaced with a stone bridge. It was one of four chantry chapels in Wakefield, the others being St John's the Baptist on Northgate, which was the parish church of Wakefield after the collapse of All Saints (this was almost entirely rebuilt, with works being completed in 1329); St Mary Magdalene on Westgate; and

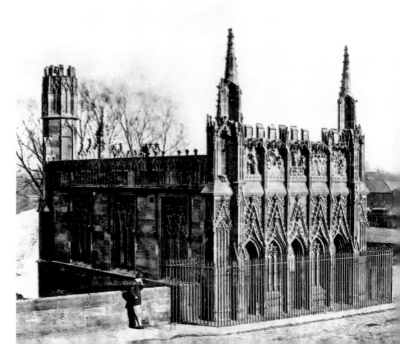

Chantry Chapel of St Mary the Virgin dates primarily from 1848, and little remains of its medieval predecessor. Here we see the chapel shortly after the radical restoration by George Gilbert Scott.

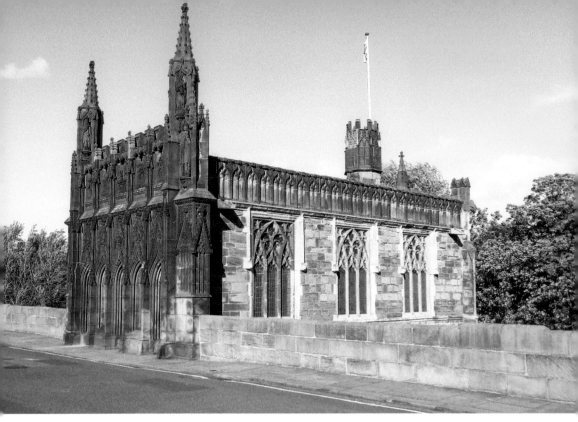

The Chantry Chapel today, with its new façade from the 1930s.

St Swithen's in Eastmoor. St Mary the Virgin was closed in 1543 as a place of worship and used for a variety of purposes until it became a place of worship once again in the mid-nineteenth century. The Chantry Chapel is one of only four surviving bridge chapels in England, a distinction that merits it being both a scheduled ancient monument and a Grade I listed building.

Much of the upper part was rebuilt in 1847–48 by George Gilbert Scott, though the crypt and stonework below pavement level is original medieval masonry. By 1939 the new front had deteriorated in the heavily polluted city air and had to be replaced. The Friends of Wakefield Chantry Chapel, established in 1990 in collaboration with the Civic Society, exist to ensure the chapel is kept in good repair and is made available to visitors. In 1995 major roof repairs were carried out, the building was rewired and new lighting and heating systems were installed. Recently the interior has undergone substantial reordering, with the removal of pew platforms, a new stone floor and new seating. The Chantry Chapel is now under the authority of the Dean and Chapter of Wakefield Cathedral.

# Chalmers, Revd Andrew

Andrew Chalmers was born in 1840 and was educated at the universities of Heidelberg and Berlin and thence undertook ministerial training at Manchester College, Oxford. His first appointment was at Oldham, where he was responsible for the construction

of the new chapel. From Oldham, he moved to be minister at Cambridge, which was then a relatively new congregation. He moved to Westgate Chapel in 1881 to replace Revd Squeirs. He married the daughter of W. T. Marriott, worsted spinner and for many decades chairman of the congregation.

In 1894, Chalmers provided a community institute endowed with some 1,600 books for Fetterangus, his home town in Scotland. In 1891, he published a collection of hymns for the use of the congregation, much as Goodwyn Barmby had done in 1860. In 1901 he produced a collection of litanies and chants, with music set by Jeremiah Dunnill. Both these books are still used by the congregation today.

In 1906 Revd Chalmers organised the restoration of the Westgate End Cemetery. He retired in 1909 and returned to his native Scotland. For some years previously he had been chaplain to the chairman of the West Riding County Council. He died in 1912 aged seventy-one. He was cremated at Lawnswood, with his ashes being interred at Hythie, near Fetterangus. A memorial tablet was erected, notable its fine profile portrait sculpture of him, at the foot of the pulpit stairs. His epitaph reads 'more light'. It is taken from Goodwyn Barmby's book *Aids to Devotion*, whereby light is associated with 'the light of true reasoning, the light of love is stronger than war, the light of knowledge, reason and science'. Fitting words indeed for a man of great intellect and ability. His son, T. M. Chalmers MA took an active part in the life of the chapel.

# Clarkson, Henry

Henry Clarkson (1801–96) was the second son of John Clarkson, who owned a mill at Westgate Common. John Clarkson was a lifelong Westgate Chapel member and

Henry Clarkson was a railway surveyor for George Stephenson and was a prominent and active Unitarian.

died aged ninety-two. He lies buried in the chapel yard and his tombstone records the epitaph 'Strange that a harp of a thousand strings should stay in tune so long'. By trade, Henry Clarkson was a surveyor and for a time worked with fellow Unitarian George Stephenson, surveying much new work for the then rapidly expanding railway network. He took an active part in local affairs, subscribing to the Mechanics' Institute and Clayton Hospital – both had strong links to the chapel. He was a Unitarian all his life and appointed chapel trustee in 1838, and from 1844 to 1895 he was secretary to the chapel and trustees, conducting the whole of its administrative affairs.

He married three times. His sons all predeceased him and his daughter Louisa Jane died in 1916. He died at the great age of ninety-five and was buried in the chapel yard. He had been persuaded to write his memoires by his friend and minister Revd Andrew Chalmers; they were first printed in 1887 and later published in 1977 in *Memories of Merry Wakefield*.

# Church Institute, The

The Church Institute stood on Marygate, opposite the head of Queen Street. Alongside to the west was the Old Corn Exchange and Manor Bakehouse. The origins of the Church Institute go back to the Church Extension Act of 1843 which witnessed the creation of three new parishes in Wakefield: Holy Trinity, St Andrew's and St Mary's.

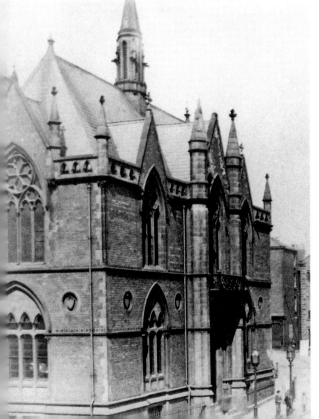

The Church Institute stood on Marygate. It was demolished in the 1960s to make way for brutalist architecture.

On 24 November 1845, Revd T. B. Parkinson organised a meeting to consider the formation of a church institution, with its objects being to advance the principles of the Church of England, the promotion of general knowledge in subordination to religion, the cultivation of church music and the encouragement of friendly social intercourse among all classes of churchmen. These main aims clearly highlight the way in which the Established Church saw itself as a civilising power. The motion was carried and the first premises were a large house in Crown Court, which was destroyed by fire in 1858. From here, the institution moved to Queen Street and then a room in the Mechanics' Institute, then to a shop in Wood Street. In 1862 the site of the medieval Manor Bakehouse was bought for £735 and Mr A. B. Highman prepared plans for the new building. The new hall cost £2,350 to build and provided a library, newsroom and lecture hall. For some years the Church Institute was very successful, providing weekly lectures to its members on science, art or literature, as well as entertainments of a lighter character. The building was eventually closed and the institution wound up in May 1911. The building was demolished in January 1964.

# Clayton Hospital

The original Clayton Hospital buildings stood in Dispensary Yard, off Northgate. Clayton Hospital is named after Thomas Clayton, former Mayor of Wakefield, and was founded in 1854. The new hospital was an amalgam of Wakefield General Dispensary (founded in 1787 for outpatients) and the Wakefield House of Recovery (founded in 1826, tending to poor inpatients suffering from infectious diseases). In 1863, Mayor Clayton financed an expansion and the institution was renamed the Clayton Hospital and Wakefield General Dispensary. The site moved from Dispensary Yard to the present site in 1876 and the new building was opened in 1879.

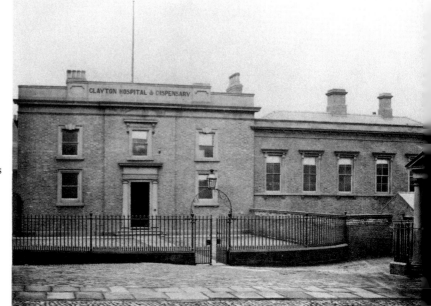

Clayton Hospital on Wood Street was demolished in the 1960s to make way for a humdrum modernist office block.

Clayton Hospital (1879) is seen here c. 1910.

The Old Clayton Hospital building became City Chambers from the 1880s onwards, with the opening of the new buildings from 1879. The old premises were demolished in the 1960s. An empty block of modern retail units stands on the site of the first Clayton Hospital on Wood Street.

# Corn Exchange

At the top of Westgate stood one of Wakefield's grandest and most important buildings, the Wakefield Corn Exchange and public buildings.

Parts of the ground floor on Westgate were let to businesses; those on the right of the image were occupied by the Prudential Assurance Co. Ltd, superintended by George John. In the centre Charles Clay & Co. agricultural engineers had premises, and on the left was the officer of clerk of the market – Mr James Jordan at the time the photograph was taken. Designed by W. L. Moffat of Doncaster, it was opened in 1838 and enlarged in 1864.

The corn trade in Wakefield can be dated back to the 1630s when the first corn market was held in booths set up on Westgate. Due to water transportation the market grew in size and importance. The inconvenience of the open-air market led to the first Corn Exchange being opened in 1820. This ventured failed, however, and a new company was formed in 1836, the Wakefield Exchange Company, who erected a larger and more imposing building. A plot of land covering 2,000 square feet at the corner of Queen Street and Westgate was purchased to build the new exchange. The shops and houses on the site were demolished and construction commenced soon after 10 March 1837. The foundation stone was laid on 24 May 1837, with a celebratory meal being held at the neighbouring Great Bull Hotel. The 1864 enlargement created the 'Grand Saloon', which was used for concerts, balls and other social events. From 1911 the Grand Saloon became the Grand Electric Cinema, and the corn market itself was converted into a billiard hall. The Grand Electric Cinema closed in 1959. The building was demolished in 1962 after a small fire damaged parts of the building, robbing Wakefield of one of its finest buildings.

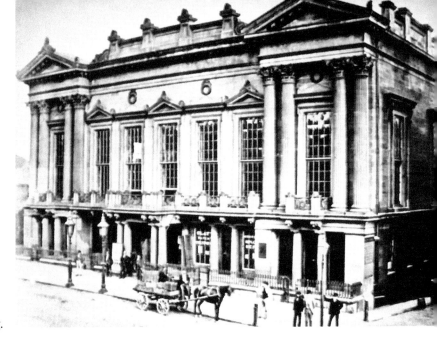

The Corn Exchange stood at the top of Westgate. Its demolition robbed Wakefield of a fine, classically inspired building.

# Courthouse

Land was purchased in 1806 and the courthouse was built for the West Riding magistrates to a design provided by Charles Watson, an architect based in Doncaster who was also architect of the St John's and South Parade developments and West Parade Wesleyan Chapel. A delay in completion was reputed to be because there were problems obtaining large enough blocks of stone for the pillars, but quarter sessions were held there from 1810. The building was extended in 1849–50 and again in the 1880s. County courts ceased to be held there in 1992, and at the time of writing the building remains empty and shrouded in plastic sheeting.

One of the first neo-Greek buildings in England was the Court House on Wood Street. The building is an empty shell, but we hope one day this landmark building will be restored to its former glory.

# Drake, Charles Henry

Born in Hartshead in 1894, Charles Drake came to Wakefield in the 1920s following a career in the army. He served as a sergeant musketry instructor in the King's Royal Rifle Corps. In 1924 he co-founded Drake & Warters Ltd, joiners and shopfitters. The company flourished and a large purpose-built factory was completed off Thornhill Street in 1933. The company built seventy-two Landing Craft Assault boats in the build-up to D-Day, and after the war built over 100,000 prefab houses that could be found across the United Kingdom. At its peak, the company employed over 300 members of staff. The company filed for bankruptcy in 1975. Drake died in 1964 and his funeral was held at Westgate End Methodist Chapel. He was survived by his widow Lilly and two daughters, Jeane and Shirley.

Here we see the staff of Drake & Warters with the company's large flatbed lorry, c. 1930.

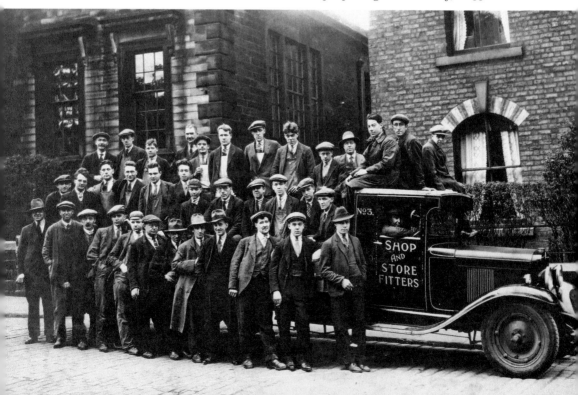

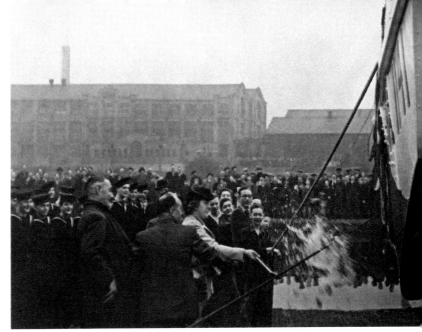

During the Second World War Drake & Warters built seventy-two Landing Craft Assault boats, many of which were used for D-Day. Here the first is launched on 13 October 1943.

# Dickens, Charles

Charles Dickens, perhaps the most famous author of his time, came to Wakefield on 9 September 1858 to give a reading of *A Christmas Carol* in the saloon of the Corn Exchange to a 'large and, on the whole, select' audience. Neither of the Wakefield newspapers of the time gave much space to an account of the event, but *The Wakefield Express* (a liberal and Nonconformist paper first published in 1852) made a point of the appalling behaviour of a prominent group in the audience: 'Some ladies, who by their position in the very front of the stalls might naturally be expected to have known better, had the bad taste to leave their seats during the last quarter of an hour's reading when the general attention could least bear to be disturbed.' As they left, others in the audience hissed. This is the only time the great man came to Wakefield.

# Dykes Family

John Bacchus Dykes (10 March 1823–22 January 1876) was an English clergyman and hymnist, and he was a Wakefield lad. From 1841 his father was manager of the Wakefield and Barnsley Union Bank. He was a natural musician and became the organist at his father's church when only ten years old. At the age of twelve Dykes became assistant organist at St John's Church in Hull where his grandfather was vicar.

He studied at Wakefield and St Catherine's Hall in Cambridge. In addition to his gift for writing music, he played the organ, piano, violin and horn. He is thought to be the most representative and successful composer of Victorian hymn tunes. His brother Frederick was choirmaster at Wakefield Parish Church and lived on South Parade. Frederick succeeded as manager of the bank upon his father's retirement.

# Egremont House

Now the Register Office, Egremont House was built soon after 1810 by John Egremont, husband of Hannah Crowther who had inherited her father's wealth, which he had gained as a wool-stapler. Typical of many houses of the period, the front is built of good quality bricks, but the sides and back are of inferior quality. After several changes of hands the house came into public ownership in 1869 and was acquired by the Rivers Board. It was bought by West Riding County Council in 1951.

Egremont House on Northgate is today the Registry Office for Wakefield.

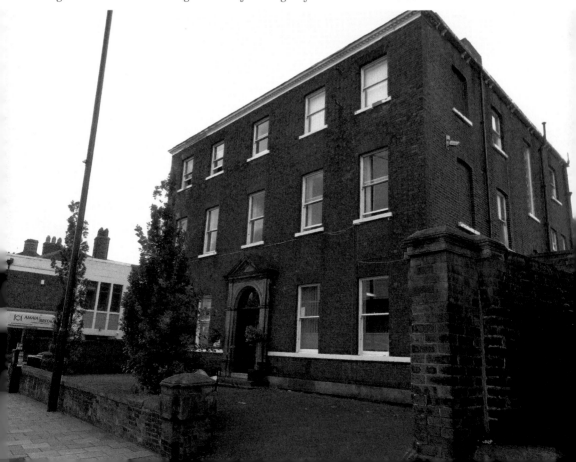

# Empire Theatre

The Empire Theatre, later the Gaumont Cinema, opened in Kirkgate in 1909. The architect was Frank Matcham, who had been responsible for the Theatre Royal and the Opera House on Westgate in 1894. The Empire Theatre was converted into a cinema in 1931 but was demolished in the 1950s. All that remains today is the row of Victorian shops to the left of the image. The characterful Georgian and Victorian buildings have been replaced with humdrum architecture of little character.

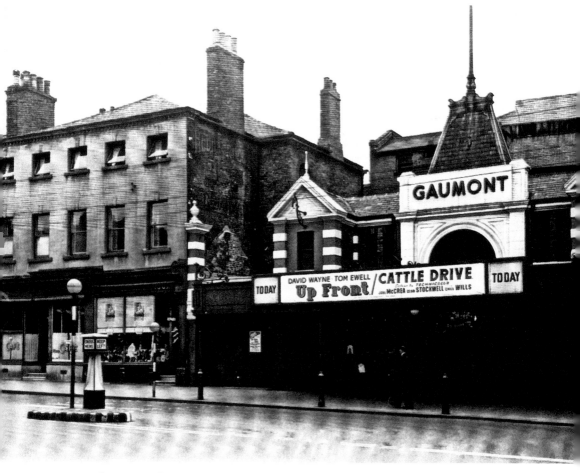

Empire Theatre stood on Kirkgate. It was a gem of an Edwardian Theatre, yet it was demolished to make way for newer, prosaic architecture.

# Fennell, Louisa

Louisa Fennell is best known for her exceptional paintings of Wakefield, which can be seen this book. She was born in Wakefield on 30 September 1847 as one of eight children to wine merchant William Fennell. Members of the Fennell family were Unitarians. Louisa was the art tutor at the Wakefield School of Art in John Batty Tootal and had studied under Thomas Cromek. She gained a first-class medal in the Wakefield Fine Arts and Industrial Exhibition of 1865. The family's burgeoning wealth meant she had no need to sell her paintings, but she did publish a book of twelve engravings in 1881. She died in 1930 and is buried at St John's Church.

   Wakefield Civic Society unveiled the latest in its rising collection of blue plaques at a special event at the Hepworth Wakefield on Saturday 8 September 2018 to commemorate her life. The plaque was the idea of Dream Time Creative. Sarah Cobham, director of Dream Time Creative and visionary behind the Forgotten Women of Wakefield project said,

> Louisa is such an interesting character, she hides in plain sight here in Wakefield. There are glimpses of her paintings on post cards and sometimes never before seen pieces of hers just turn up in galleries or in private collections, some of which I have had the privilege to see. She seemed to be a very private person so I am not sure how she would feel about a Blue Plaque dedicated to her so publicly, however working with Wakefield Civic Society and The Hepworth Wakefield on this project has strengthened my determination to bring more women like her out of the shadows and into the light.

# G

## Gaskell, Benjamin

Gaskell Street is named after members of the Gaskell family, who were prominent citizens of Wakefield. Brothers Benjamin and Daniel Gaskell both affected changes and improvements to education and other causes in Wakefield and Yorkshire as a whole. The brothers were Members of Parliament; indeed, Daniel was the first MP for Wakefield. Yet both men have slipped out of the consciousness of Wakefield's past and few people have heard of either man.

Benjamin Gaskell was born on 28 February 1781, the first son of Daniel Gaskell of Clifton Hall, near Manchester, and Hannah, daughter of James Noble of Lancaster. He was educated at Gateacre, near Liverpool. Then between 1796 and 1797 he attended Manchester Academy, which was a Unitarian educational establishment founded in 1789 as part of Moseley Street Chapel, which moved to Upper Brook Street in 1839. The congregation had been founded by Revd William Turner, minister of Westgate Chapel. Benjamin then studied under the radical Revd Thomas Belsham at New College Hackney. Classmates of Benjamin Gaskell were the radical William Hazlitt, as well as Charles Wellbeloved, who became minister at York Unitarian Chapel. Benjamin then studied for a BA at Trinity College, Cambridge, starting in 1800.

Benjamin joined Lincolns Inn in 1804. With the death of his great-uncle James Milnes, he inherited his estates. The will decreed that Benjamin would inherit Thornes House as long as provision was made for Daniel to have his own estate, resulting in the purchase of Lupset Hall. Daniel had lived at Thornes House with James Milnes as a companion since the death of James Milne's wife. The Milnes family had been associated with Westgate Chapel and its congregation since the start of the eighteenth century and had been instrumental in building the new chapel of 1750. On 17 June 1807 Benjamin married Mary Brandreth of Broad Green Hall, Liverpool. Their son James Milnes Gaskell was baptised at Thornes House by the minister of Westgate Chapel, Revd Johnstone.

In 1806 he stood for Maldon in Essex, associating himself with the promotion of a new charter for the borough – he narrowly won the seat, but was unseated on petition and defeated by Western at the ensuing general election. He became MP for Maldon in 1812 and held the seat until June 1826. Gaskell lived abroad in

1827–78, but thereafter led 'a life of quiet retirement and unostentatious goodness' at Thornes, where William Ewart Gladstone (the Eton and Christ Church friend of his only child James Milnes Gaskell, Conservative Member for Wenlock 1832–68) was a guest in 1829 and 1832.

In local education, Benjamin Gaskell supported a mixed-sex infant school for sixty children, which he had established in 1829; a girls' school capable of teaching thirty-five; and a Sunday school that taught sixty children. Both he and his brother were governors of York Pauper Lunatic Asylum. In 1824, 1825 and 1826 Benjamin subscribed to the Yorkshire Musical Festival, which raised funds for the York County Hospital as well as the general infirmaries of Leeds, Hull and Sheffield. He is perhaps best known as supporting the foundation of St James's Church, Thornes, in 1830. On 26 July 1830 he was commissioned as Deputy Lord Lieutenant of Yorkshire along with Samuel Stocks, a prominent Wakefield Wesleyan Methodist. He died in January 1856 and is interred in the catacombs below Westgate Chapel. His wife pre-deceased him and is buried under the altar at St James with Christ Church Parish Church, Thornes. She was opposed to her husband's Unitarian views. He died in the new year of 1856 after a visit to Carlisle where he gave liberally to found the Mechanics' Institute there, which was managed by Revd Goodwyn Barmby.

*Below left*: Benjamin Gaskell MP of Thornes House in a portrait of *c.* 1820.

*Below right*: Monument to Benjamin Gaskell of Thornes House in Westgate Chapel.

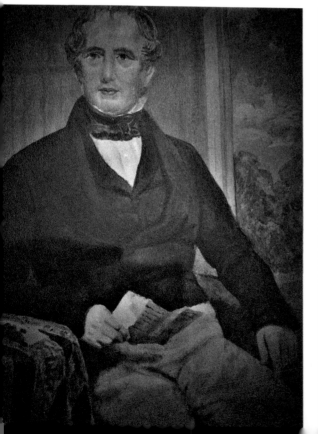

# Gaskell, Daniel

Daniel Gaskell, brother of Benjamin Gaskell, was born on 11 September 1782. He was educated at William Shepherd's School at Gateacre, Liverpool, and under Thomas Belsham in Hackney. He came to Wakefield to be company for James Milnes at Thornes House. When Milnes died in 1805 his trustees purchased Lupset Hall estate for him, where he lived from 1806 until his death. He married Mary Heywood, daughter of Benjamin Heywood of Stanley Hall. Lupset Hall 'received all the embellishment which taste and art could confer upon it' and became 'the seat of the most liberal hospitality'. Gaskell was acquainted with prominent figures, such as the philosopher and social reformer Jeremy Bentham, although Mary Shelley considered him and his wife to be 'country folks in core'. William Gladstone, the great nineteenth-century statesman would visit the Gaskells at Lupset Hall.

Described by the novelist Mary Shelley as 'a plain licentious but intelligent looking man', Gaskell served as MP for Wakefield from 1832 until his defeat in 1837. He was one of around forty Unitarians who sat in the Commons during the 1832–68 period. The radicals in the newly enfranchised borough of Wakefield invited Gaskell to be their candidate. He initially accepted but subsequently withdrew. He was, however, persuaded to reconsider. In August 1831, his nephew James Milnes Gaskell, who had begun canvassing Wakefield as a Conservative, recorded that 'the radicals had so effectually worked upon my uncle's anxious and sensitive mind that he considered it a point of conscience' to stand. Milnes Gaskell withdrew in his uncle's favour in March 1832, finding a safe seat at Wenlock instead. Gaskell was elected unopposed in December 1832 when his political platform included retrenchment in public spending, shorter Parliaments, the secret ballot, the abolition of slavery, revision of the Corn Laws and reform of the Church.

Alongside local radical pressure, Gaskell's formidable wife Mary played an important part in encouraging her 'reluctant spouse' to stand. Although women were debarred from the parliamentary franchise, their political influence in this period should not be overlooked – whether as local voters, petitioners, electoral patrons or, in Mary Gaskell's case, political wives. 'Unquestionably a character' who 'drew upon herself a great degree of notice from the leading part she took in public matters', she was described as 'a sort of zealot in the patronage of ultra-Liberals'. She went to hear sermons from the Unitarian preacher William Johnson Fox (later Liberal MP for Oldham) and 'was a kind and generous friend' to the radical journalist and novelist William Godwin and his family, including Mary Shelley, his daughter. In April 1831, James Milnes Gaskell told his mother that 'it is, in fact, my Aunt, that would be member of Parliament'.

Despite his initial reluctance to stand Gaskell was 'punctual in his attendance' at Parliament. Mary Shelley marvelled that 'he attends the house night after night and dull committees and likes it! – for truly after a country town and country society, the dullest portion of London seems as gay as a masked ball'. While Gaskell gave

general support to Whig ministers, he expressed concerns that they 'did not proceed in the path of Reform so rapidly as was generally expected; indeed, some of their early measures seemed to indicate a retrograde movement'. Reflecting his claim that 'I have attached myself to no party', Gaskell's votes in the division lobbies displayed considerable independence. He often divided in the minority with radical Liberal and Irish MPs on issues ranging from the ballot to the introduction of a moderate fixed duty on corn. His radical leanings prompted joint Whig-Conservative efforts to find an opponent to him at the 1835 election. He survived this contest but was defeated in 1837. His parliamentary service was rewarded with the presentation of 'two massive pieces of silver plate' in 1838: a vase from the 'ladies' of Wakefield and a soup tureen from 1,700 male subscribers.

After several years' absence from the Commons, Gaskell reluctantly agreed in December 1845 that he would stand again for Wakefield to support the cause of free trade. With the general election delayed and the Corn Laws repealed, he withdrew in April 1847 on grounds of his age and health. Widowed the following year, he subsequently dedicated his energies – and up to half his annual income of £4,000 – to charitable works. He was a particularly generous benefactor to the Unitarian Church, donating £1,000 in 1856 to assist poorer congregations in the north of England. Along with Revd Thomas Johnstone, he promoted the Lancasterian School. He gave £1,575

*Below left*: Daniel Gaskell MP, photographed *c.* 1860.

*Below right*: Monument of Daniel Gaskell in Westgate Chapel.

to build Clayton Hospital, provided £6,000 for a school in Horbury, gave £1,000 for providing a public park in Wakefield, a further £1,000 for the removal of buildings between the parish church and Westmorland Street, £10 towards the restoration of the Chantry Chapel, and contributed £3,000 towards new premises for the Wakefield Mechanics' Institute in 1855. He died on 20 December 1875. He lies buried beneath Westgate Chapel.

# Goodchild, John Fletcher

John Fletcher Goodchild was born in Wakefield, West Yorkshire, the son of Ernest Goodchild, deputy registrar at the West Riding Registry of Deeds, and his wife Muriel (née Lee). John attended the city's Queen Elizabeth Grammar School. On leaving full-time education, he went to work in the West Riding Record Office – he ran a private museum even then, at first housed in a local chapel and open to all.

In 1966 he became founding curator of Cusworth Hall Museum, near Doncaster, which is devoted to the social history of South Yorkshire. It subsequently won a 'Museum of the Year' award for educational work. Some nine years later, he returned to Wakefield as first district archivist and principal local studies officer. However, it is his collection of manuscript material and books, the boyhood interest that became his lifelong passion, that will be his lasting legacy. Put together from private purchases as well as donations from individuals, institutions and companies, it was the most substantial collection on Yorkshire and industrial history in private hands.

His collection includes manuscripts, books, maps, portraits and illustrations from the twelfth century onwards, and is especially rich in material from the eighteenth

John Fletcher Goodchild,
historian and lifelong Unitarian.

and nineteenth centuries. John always made the collection accessible, interpreting and using it for the benefit of researchers, and it will be maintained in the care of the West Yorkshire Archive Service.

John was a member of the Yorkshire Archaeological Society (and a co-founder of its industrial history section) and of the Wakefield Historical Society, for which he served as vice president. In 1984 he was awarded an honorary master's degree by the Open University for 'academic and scholarly distinction, and for public services'.

John was a familiar figure in Wakefield, often accompanied by one of a succession of rescue dogs. He is survived by Alan, his partner of sixty years. Throughout his life he was a Unitarian and ardent supporter of Westgate Chapel.

# Goodwyn Barmby, Revd John

John Goodwyn Barmby (1820–81) was a British Victorian utopian socialist. He was a truly remarkable man in many regards. He and his wife Catherine Barmby (died 1854) were influential supporters of Robert Owen in the late 1830s and early 1840s before moving into the radical Unitarian stream of Christianity in the 1840s. Both had established reputations as staunch feminists and proposed the addition of women's suffrage to the demands of the Chartist movement. They were known by Margaret Fuller and Mary Wollstonecraft.

Barmby was involved as an editor, writer and organiser of communitarian ventures around London from 1838 to 1848. He is often associated with the growth of socialist and utopian projects during the rise of Chartism. He founded a utopian community on the Channel Islands and at times corresponded with radicals such as William James Linton and Friedrich Engels.

John Goodwyn Barmby is also known as the person who claimed to have introduced the word 'communist' into the English language as a translation of the French word *communiste* during a visit to Paris in 1840, in conversation with some followers of Gracchus Babeuf. They founded the London Communist Propaganda Society in 1841 and, in the same year, the Universal Communitarian Association. Barmby founded the *Communist Chronicle*, a monthly newspaper later published by Thomas Frost. By 1843, the Barmbys had recast their movement as a Church. He entered the Unitarian ministry without training and was accorded the title 'Revd' in 1848. It is likely he was never ordained. He was appointed minister of Newbury Presbyterian Chapel on 7 November 1849 and was later minister at Topsham, Lympstone and Southampton, where he established a new congregation, and then at Leonardgate Chapel in Lancaster. His first wife, Catherine, was a utopian socialist and a writer on women's emancipation. She died in 1854.

Barmby was one of the best-known ministers in the West Riding of Yorkshire and held his post in Wakefield for twenty-one years from June 1858, leading the Wakefield congregation, which included the industrialist Henry Briggs. He married Adah Marianne Shepherd on 30 August 1861 at Troutbeck Bridge Chapel, Windermere.

The service was conducted by Revd Edward Hawkes MA, grandson of Revd Thomas Johnstone. Adah Shepherd was the daughter of Edward Shepherd, governor of Wakefield Goal. Adah Marianne's sister Catherine married Henry Currer Briggs, son of Henry Briggs in 1863, and Eliza married George Stephen Woolly in 1864. For many years, John Goodwyn Barmby was also secretary of the West Riding Unitarian mission. He founded a daughter congregation on Primrose Hill by Kirkgate station in 1864 and, through his 'Band of Faith' movement, founded new congregations across the West Riding in Barnsley, Castleford, Clayton-West, Flockton, Heckmondwike (founded 1864) and other places. A chapel in Ossett was opened in 1867 and closed in 1880. A bazaar was held at the Orangery in 1871 to defray the cost of the 'Iron Church' at Ossett. The iron building was later erected in Selby when the Ossett Chapel closed in the late 1880s. Through the West Riding Unitarian Mission Society, he was associated in the building of a new chapel in Dewsbury. The cause here was founded in the 1780s, resulting from a schism in the Wesleyan Methodist Church as a national body. The old chapel was on Webster Hill. Through the efforts of Thomas Todd a new chapel on Swindon Street was opened 21 March 1866, which had cost £1,700 to build, through the efforts of Revd P. Cannon. It was closed in 1953. The schoolroom at Pepper Hill, Shelf, was supported by the society, as were the congregations at Elland and Pudsey where new churches had been built, as well as supporting three missionaries.

The Clayton West congregation grew out of the lectures he held at Scisset Circulating Library, which began in March 1861. The Unitarian chapel in Malton was also a beneficiary of his organising skill as he was involved with a scheme to rejuvenate the congregation and remove the £200 debt on the place. Barmby always retained his liberal political convictions and was closely involved in the Wakefield Liberal Association from 1859 – he chaired its North Westgate ward committee that year and the full town committee in 1860. Others in the Westgate Chapel congregation could be found in the association, notably Charles Morton. To mark 200 years since the great ejection of 1662, Barmby organised celebrations in Wakefield as 'they [the Unitarians] are the real descendants of the ejected, these 2,000 persons, not having a fixed creed, soon became Arian then Unitarian. They would celebrate it in spite of every opposition'. The following year he helped found the Wakefield Working Men's Institute.

He spoke with the mayor and Corporation of Wakefield in 1865 at a public meeting held in sympathy on the assassination of President Lincoln. The meeting was held in the courthouse on Wood Street, chaired by Alderman Lee, the then mayor. Barmby noted that Lincoln was a great and good man, martyred for his loyalty to duty. He was the only minister of religion to speak at the meeting. The same year he, along with Henry Briggs and Daniel Gaskell, was elected to the committee for the Liberal candidates standing in the South West Riding during the general election of that year. Furthermore, 1865 witnessed a public meeting being held in Wakefield for Religious Freedom, championing the disestablishment of the Church of England. At the meeting Barmby proposed that members of the Church of England injuriously affected the liberty of other religious bodies, in which he was supported by Revd J. S. Eastmead of

Salem Chapel. From 1859 both he and Eastmead sat on the local Wakefield Education Examination Board of the Mechanics Institution. Eastmead remained on the board until 1863, when it was joined by T. W. Gissing and W. S. Banks.

In 1867, Barmby organised a large public meeting in Wakefield in support of parliamentary reform and joined the National Association for Women's Suffrage. The Wakefield Committee of the National Society for Woman's Suffrage was founded in 1872, with Miss Julia Barmby as secretary. Sadly, with Barmby leaving Wakefield, the Wakefield branch of the society was wound up in 1882. Barmby was a member of the council of Mazzini's International League and also supported Polish, Italian and Hungarian freedom. In 1870 he became a founder of the Wakefield branch of the RSPCA. The year 1873 witnessed Barmby establish a Wakefield branch of the National Republican Brotherhood, supported by Mr Skipworth, a local solicitor. The object of the brotherhood was universal adult suffrage, proportional representation in the House of Commons, disestablishment of the Church of England, free compulsory secular education and nationalisation of land, as well as the founding of a social democratic and federal republic.

In July 1877, Barmby was appointed a member of the General Committee of Clayton Hospital, along with W. S. Banks, who for a time was a fellow Unitarian. This body oversaw the building of the current premises on Northgate. He had been involved in the building of the Albert Wing and its opening in 1863. He suffered a stroke while leading the Christmas Day service in 1879 and was unable to take any further services. Barmby retired to Oxford but continued to hold intensely devotional private services. He died there on 18 October 1881, and was buried at the cemetery of Framlingham, Suffolk. His second wife survived him. His obituary in the *Leeds Mercury* describes him as 'an ardent liberal, his last act previous to leaving Wakefield was to vote for Mr Mackie at the last General Election'. In his obituary it was stated, 'Mr Barmby was at all times the warm friend of the working classes, his sympathy and charity were unbounded; and many will gratefully remember his kindness and acknowledge his worth.'

Revd John Goodwyn Barmby, poet, communist and Unitarian minister.

# H

# Hepworth, The

The Hepworth Wakefield opened in 2011 to house Wakefield's art collection and provide a legacy for Barbara Hepworth in the town in which she was born.

The original Wakefield Art Gallery was established in 1934 and became one of the most forward-thinking galleries of its time, supporting artists such as Hepworth and Henry Moore early in their careers. With gifts from local industrialists, the gallery built a collection of works by some of the most significant and avant-garde British artists of the twentieth century. Supporting contemporary artists and developing the collection for future generations is something that The Hepworth Wakefield continues to be committed to today.

The Hepworth, Wakefield's award-winning art gallery.

# Heywood, John Pemberton

John Pemberton Heywood (1756–1835) was the fourth son of Arthur Heywood, a descendant of Oliver Heywood – the 'Puritan apostle of the north'. Despite being staunchly Nonconformist, he was admitted to Cambridge but left in 1776 without a degree. He was called to the Bar in 1780, and in the following decades built up a large practice as a lawyer.

He married in Margaret Drinkwater 1797, who brought him a £10,000 dowry. On the death of Peter Drinkwater, Margaret's father, in 1801 he inherited £10,000 from the will – then quite a considerable sum of money. This money was used to build a new large and lofty mansion on the newly laid out Wentworth Street. Today, 'Wentworth House' is home to Wakefield Girls' High School.

Upon retiring from the bench in 1811, he was instrumental in founding the Lancasterian School and was active in running and managing the Wakefield Dispensary. In 1822 he was on the committee for the 'Music Saloon' on Wood Street. He became a leading member of the Westgate Chapel, became a trustee and was the major benefactor to building a new minister's house, as well as supporting the Lady Hewley Charity along with the Gaskell brothers. His elder brother, Benjamin, built the present Stanley Hall in 1802, and was likewise a stalwart member of Westgate Chapel. Benjamin's daughter married Daniel Gaskell. John Pemberton Heywood died aged seventy-nine in 1835 and was interred in the catacombs beneath Westgate Chapel. He was called 'the friend of the people' by Henry Clarkson.

Wentworth House, home of John Pemberton Heywood.

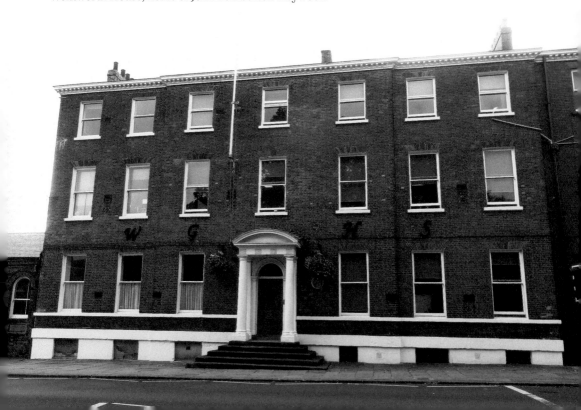

# Holy Trinity Parish Church

One would hardly believe that a fine early Victorian church once stood where a car park and industrial units stand today. The apparent lack of religious belief (or at least its practice) among the working classes and urban poor was a constant Victorian concern. Residents of nearby South Parade led the move to build a new church close to the fashionable development of South Parade. A meeting was held on 11 April 1838 at the Rolls Office, Manor House Yard, Kirkgate, to discuss the building of a new church. The new church was to be in the Gothic style and seat 600 people in the body of the church and 400 in the galleries. The committee, headed by the Mr Dawson, the honorary secretary, noted that the building was to cost no more than £2,500. Plans prepared by Mr Billington were accepted. The church was opened in 1839, but not until 10 October 1844 did it become a parish church. A chancel was added sometime later. The church was attended by the Dykes family and closed and demolished in 1954.

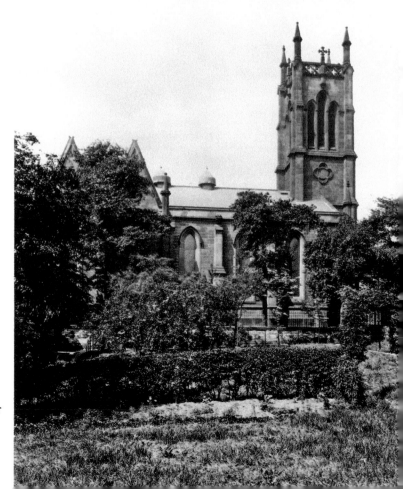

Holy Trinity Church stood on George Street. Here we see the exterior as it was in 1880.

# Indigo Dye Works

The mercantile development of Wakefield in the eighteenth century was dominated by Westgate Chapel families. The Milnes family controlled the sale of large quantities of undyed white wool broadcloth. Keen to provide more than white cloth, Robert Milnes had constructed a dye works at Belle Vue on the river frontage shortly before his death in 1734. The dye works were managed by the Lumb family until purchased outright in 1775 by Robert Lumb, who then sold the works to Joseph Holdsworth in 1789. The Holdsworth family had been associated with the dissenter chapel at Westgate End since 1697. Stephen Holdsworth (1705–61) was superintendent of the building of the current Westgate Chapel, which replaced the chapel at Westgate End in 1752.

With the failure of the banking firm of Wentworth Chaloner and Rishworth in 1826, it brought about the collapse of J. & J. Naylor, a major Wakefield cloth firm that owed the dye works a staggering £12,765 19s 4d – a veritable fortune at the time. Joseph Holdsworth died in July 1826 and was succeeded by his son Joseph (1789–1857). The business staggered on but was given up in the 1870s. The site of the works was purchased in 1904 by the Yorkshire Electric Tramways Syndicate Inc. and become a tram depot, which is now a bus depot.

# J

## Johnstone, Revd Thomas

Thomas Johnstone (1768–1856) was born at Stanstead, Essex, in November 1768. He was educated under Revd Thomas Belsham at Hackney from 1788 to 1789. He was appointed minister at Westgate in 1792 – his only appointment. He married Martha, the daughter of John Milnes of Flockton Hall in 1793. They had a large family, some nine girls, of whom only two died in infancy. With the death of Revd Turner in 1794, he became the minister with a considerably increased stipend.

Johnstone was a man of left-wing radical politics, supporting the goals of the French Revolution, and was threatened with imprisonment for treason if he did not curb his vocal and public support for Robespierre. He remained active in politics, agitating in favour of the Chartist and the Reform Act of 1832. He agitated for the abolition of slavery and the slave trade in 1807. William Wilberforce had visited the chapel in the 1790s while a guest of James Milnes at Thornes House. Milnes was an associate of the marvellous Charles James Fox. Indeed, the congregation grew to such an extent at this time that the gallery had to be extended along both side walls of the chapel.

Johnstone's ministerial duties were light and he gained something of a reputation for repeating his sermons. He baptised the son of Benjamin Gaskell in the secular setting of Thornes House. He augmented his income by running a girls' school of middle- and upper-class girls from the age of fourteen to eighteen, which taught English, the classics, history, geography, astronomy, science, natural history and evidence of Christianity. Boarders at the school pad £80 a year and scholars a more modest £15.

He married for a second time in 1831 – to Elizabeth Lumb. As part of the marriage settlement his bride's father, Richard Lumb, would pay £500 a year to the maintenance of the chapel. Upon this second marriage, he retired from the ministry in 1833. He took an active part in local society and was instrumental in the founding of the Lancasterian School and the Mechanics' Institute. He lived as a tenant in the chapel manse until 1846, when he moved to Hatfield Hall to live with his son. He died on 25 April 1856 at the then great age of eighty-seven. He is buried in the catacombs beneath Westgate Chapel.

# Kirkgate Railway Station

The North Midland Railway was the first company to bring a line to Wakefield. The line ran from Leeds to Derby and was opened on 30 June 1840. Wakefield's station was 3 miles away at Oakenshaw. Joseph Hunter, a South Yorkshire historian, noted that he travelled from Oakenshaw to London in eight hours or less, the time of the journey being something marvellous as it had previously taken a couple of days. The first line to pass through Wakefield was the Manchester to Leeds line – later the Lancashire & Yorkshire Railway. The line ran from Manchester to Wakefield and then via Normanton to Leeds. George Stephenson was the engineer and commenced work in the summer of 1838. The most important engineering projects were the viaduct over Kirkgate, the Park Hills cutting and the bridge over the River Calder at Kirkthorpe. The construction of the line was opposed by the Aire & Calder Navigation Company, which ran practically alongside the railway throughout a great proportion of its course. An injunction was brought by Aire & Calder to prevent the building of a viaduct over Kirkgate, but on 10 March 1840 the York magistrates allowed for the erection of a three-arch viaduct over Kirkgate, though a single-span bridge would have been preferable. In 1900 a new single-span bridge was erected when the line to Barnsley was widened. The first Kirkgate station was opened on 5 October 1840 on the site of Aspdins Portland Cement works, which later relocated to Ings Road until its closure in 1892. The station was a small wooden hut with a platform in front, apparently with 'miserable waiting room accommodation'. The present station, with a classical stone façade, dates from 1854 and was built with grain warehouses adjoining.

Kirkgate railway station was virtually derelict for many years, but has been recently restored.

# L

## Lee, John

Coal baron and lawyer, John Lee was the mastermind behind the St John's development at the close of the eighteenth century. He was born on 21 August 1759, the son of Thomas Lee. He was admitted as a solicitor in 1780, while at the same time, in association with Francis Maude, began buying up land to the north of Wakefield. In May 1788 permission had been granted to build a new church in Wakefield, to be paid for by a £1,000 endowment of Mrs Newstead. The new church was to be the centrepiece of a new housing scheme developed by Lee, Maude and their associate General Loftus Tottenham. Plans were drawn up by Charles Watson. St John's North was completed in 1796 and St John's Square was begun in 1798. This was part of a grand plan for a new town that ultimately failed to materialise.

John Lee's interest in the Lake Lock Railroad, the world's first public railway, provided ample funds, as did his investment of client's funds. He proposed a new town development at Stanley around the then new St Peter's Church, but this failed through lack of demand. Ultimately, his backers called in their funds after the financial crash of 1826/27 and his last years were marked by fiscal challenges, although he did pay for the building of Balne Mill for his son Tottenham Lee. This venture failed and it was bought out by W. T. Marriott. John Lee died in 1836 and his tomb may still be found in the crypt beneath St John's Church.

## Lumb Family

The founder of the Lumb dynasty in Wakefield was John Lumb (1690–1768), who married Sarah Milnes, the daughter of Robert Milnes and Hannah Poole. He built Silcoates House in the 1740s. His son Richard (1726–1807) lived in Ackton Hall, near Pontefract. Richard's son Samuel Lumb (1760–1805) married Hannah Holland in 1789, which brought him a dowry of £2,000, then a vast sum of money. However, he was mentally unwell, and was committed several times to hospital care. He separated from his wife in 1795 and paid her £120-a-year maintenance. Hannah Holland left Wakefield to live in her native Cheshire with her niece Elizabeth Gaskell, the great

Victorian novelist and wife of the Unitarian minister Revd William Gaskell. Samuel Lumb left four illegitimate children born to him by his common law wife Esther Scrimshaw.

John Lumb, son of John Lumb Snr who built Silcoates, married Anne Milnes, cousin of the internationally known poet Esther Milnes Day. Anne has left a charming narrative of her life at Silcoates hall in a diary, soon to be republished by Westgate Chapel. She, like her husband, lie in the catacombs beneath Westgate Chapel. His brother Robert also lies beneath Westgate Chapel, along with brother Richard and their wives. John and Anne had but one child, Thomas Lumb.

Thomas Lumb in 1782, when aged twenty-eight, married a penniless young lady of apparent aristocratic background, and he and her father eventually became business partners together. They were highly successful wool-staplers and cloth merchants. They had warehouses not only in Wakefield but also Leeds and Huddersfield. He embraced technology and new ideas, and he erected the second steam-powered mill in Wakefield, at Silcoates. A charismatic man of great ability, he took an active part in the affairs of the Wakefield Dispensary and Wakefield Library. In local affairs he subscribed to Westgate Chapel Sunday School from 1785, rebuilt the village school in Alverthorpe, subscribed to Hackney Academy, and backed the Wakefield newspaper – the *Wakefield Star* – when refounded in 1804. He attended Wakefield theatre and the races. He died on 22 December 1813 aged fifty-nine. He lies in the catacombs beneath Westgate Chapel. His will of 3 July 1812 gave his house and lands and Silcoates to his wife Lucy (née Kendall).

# M

## Marriott, William Thomas

William Thomas Marriott was the third generation of the family to be worsted spinners. His grandfather, Thomas Marriott, had set himself up at Flanshaw Mill in 1815, one of the first mechanised mills in Wakefield and he and his son William had built new mills at Westgate End in 1822 and a handsome new home on South Parade. William later built the now long demolished Plumpton House. Both his father and grandfather died in 1832 and the business being passed to his mother. Both men were interred in the burial yard of Westgate Chapel.

The mill at Westgate End was enlarged in 1831 and 1857, and William Thomas formerly became a partner in 1851, and married in 1853. A disagreement with his brother Aldred witnessed the closure of the Westgate End mill in 1871, but business carried on at Balne Mill, built for Tottenham Lee. The Westgate End mill stood derelict until the very end of the nineteenth century, when it was demolished and the current terrace – called 'Plumpton' – was built.

Sandal Grange, the home of W. T. Marriott from the 1860s onwards.

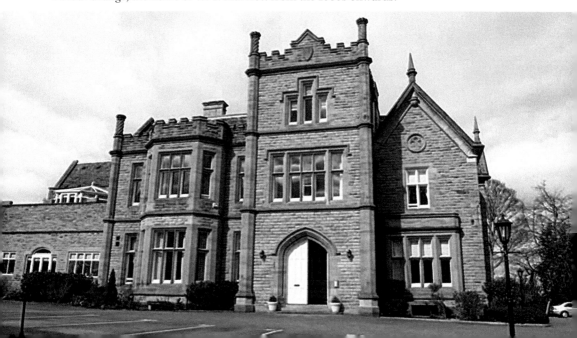

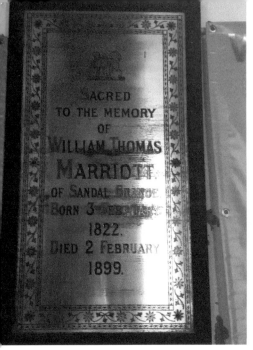

*Above*: No. 10 South Parade was built by
Thomas Marriott in 1826. He was the father of
W. T. Marriott.

*Left*: Brass memorial tablet to W. T. Marriott in
Westgate Chapel.

In the 1850s and 1860s Marriott's business was the largest and most prosperous in Wakefield. He prospered so much in 1867 that he purchased Sandal Grange for the then immense sum of £15,059 8s 0d. Marriott also had an interest in Newton Colliery at Snow Hill and Wrenthorpe Colliery. In 1892 Wrenthorpe Colliery had to close for eleven weeks to repair the machinery; rather than let his workers go without pay, he paid them wages for eleven weeks from his own personal funds.

During his lifetime he gave vast sums for the establishment of Clarence Park and the rebuilding of Clayton Hospital, as well as for the establishment of the Yorkshire College, which is today the University of Leeds. He and his wife, like his parents before him and his grandfather, were lifelong Unitarians and active members of Westgate Chapel. He died in 1899 and is buried in the chapel yard, next to his parent's graves. As a mark of respect, the bells of the cathedral tolled throughout his funeral service at Westgate Chapel. His daughter marred Revd Andrew Chalmers and his son carried on the spinning business until 1910.

# Market Cross

At some time in the seventeenth century, the memorial cross that had been set up by Edward IV to commemorate the death of his brother Edmund, Earl of Rutland, was moved from Kirkgate to a site on Westgate. The cross survived the Civil War and was still standing in 1684. In approximately 1700 the inhabitants of the town complained that the marketplace had become so infilled with permanent shops, rather than temporary booths, that no convenient place existed for the sale of butter, eggs, poultry, etc. In 1707 a plan was agreed to erect a market cross with a chamber over, the cost being defrayed by public subscription.

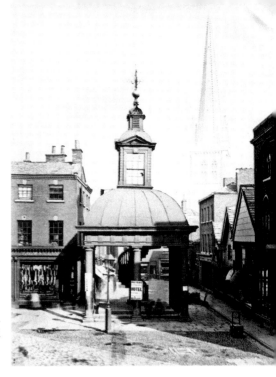

The market cross as it once was in Cross Square. This photograph is one of the oldest of Wakefield and predates 1866, the year when the elegant building was demolished.

The market cross was a square, open colonnade of eight Doric columns supporting a vaulted chamber that was covered in lead and supported by a domed lantern, surmounted by a weathervane. A winding wooden stair led to the chamber in the roof, in which the street commissioners, constables and town overseers met. The steps were used to sell eggs, poultry butter, eggs and sundry goods. The market cross was demolished from 19 September 1866 at the request of shopkeepers in Cross Square. Two of the stone columns were moved to Alverthorpe Hall, two to Outwood Lodge and two to Wakefield Museum. The fate of the remaining two is not known. The bell, which dated from 1655, was purchased for £2 and is now housed in Wakefield Museum.

# Marygate

Marygate is one of the older streets of Wakefield. As the medieval marketplace became infilled with permanent booths and stalls, new streets such as the Shambles, Bread Street, Little Westgate, Silver Street and Marygate threaded their way between the buildings. In the Middle Ages Marygate was the site of the manor of Wakefield bakehouse. It was here that all those desiring to make bread or pies and pastries had to come to bake them. Householders were forbidden from having their own bake oven and had to pay the lord of manor for the privilege of baking their bread or pastries. The bakehouse was standing by 1354 and was demolished in 1860.

Also here was one of the town gaols – after which the street 'Prison Lane' was named. In 1316, Thomas Maufesour was found guilty of stealing two mares in the Moot Hall during a session of the manor court. He was imprisoned in the Manor of Wakefield Gaol, and then taken and hung by the neck in Agbrigg until dead. In 1383

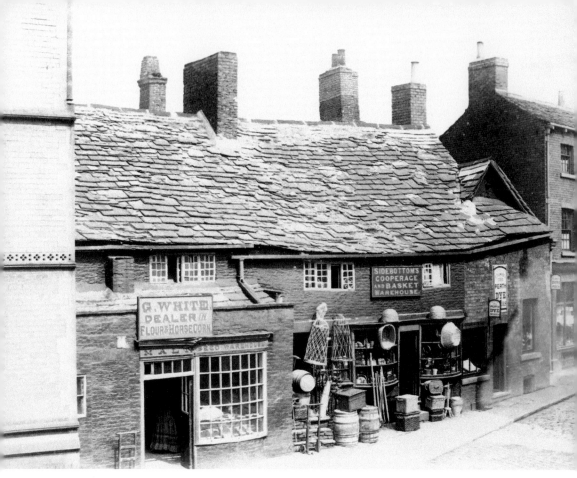

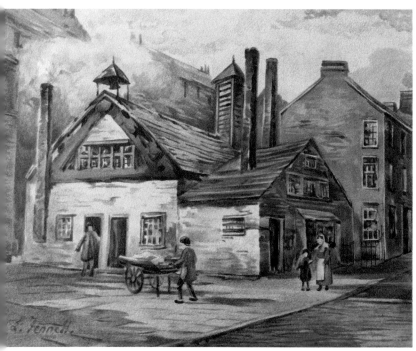

*Above*: Marygate, one of the medieval streets of Wakefield, once boasted these charming late medieval cottages.

*Left*: Marygate Manor Bakehouse, as painted by Louisa Fennell, before its demolition to make way for the Church Institute.

the gaol chamber was 24 feet long and 16 feet wide, beneath which was the gaol, described as a vaulted cellar and accessed by a winding stair. When the old houses were demolished in 1901, workmen came across the remains of this prison. The cell was estimated to be 12 square feet and was made from large blocks of sandstone and oak beams. The other prison, for the borough court, stood at the bottom of Northgate on what was then known as 'Bitch Hill'. The Manor Bakehouse was also on Marygate, until it was demolished to make way for the Church Institute.

# Methodist New Connexion

The Methodists of the New Connexion were a splinter movement from the Wesleyan Methodist Connexion and was founded in the 1790s. The members wanted each chapel to be virtually self-governing and follow the ideals of the French Revolution. They were known as 'Tom Paine Methodists' for their support of the *Rights of Man*. Members of Thornhill Street Wesleyan chapel split in 1798 and met in what was the New Assembly Rooms in George and Crown Yard. They built a chapel on Grove Road in 1866, which closed in 1978.

The New Assembly Rooms, Crown Court. Originally built as a dance hall, over the years it has been a Methodist chapel, the Town Hall for Wakefield, an organ-building factory and is now residential apartments.

Grove Road Chapel opened in 1866 was the only chapel of the Methodist New Connexion in the city. It was closed in 1978 and, after nearly thirty years of neglect, was converted into residential units.

# Milnes, James

James Milnes (1755–1805), heir to a wealthy Wakefield woollen merchant, was not interested in business and instead favoured politics. On the death of his father, also James Milnes, who was a religious dissenter and a prominent local supporter of Pitt, James Jr quickly showed contrary political tendencies to becoming an ardent Whig. At the general election of 1796, evidently at the instigation of Lord Lauderdale, Milnes was lured into a contest for Shaftesbury in company with William Dawson, whose family had been business associates of his. Told that the outlay would probably be £4,000, the total cost was £17,000 and he failed to win the election. In 1802 he was elected to Parliament. In Wakefield he built Thornes House, completed largely by 1781 and designed by John Carr. He supported the Lady Hewley Charity and was deputy lieutenant for the West Riding of Yorkshire.

Milnes died on 21 April 1805. The great William Wilberforce described him in 1795 as 'good natured and well intentioned' and an obituary commended his 'urbanity of manners and inflexible integrity in public and private life'. He is buried in the catacombs beneath Westgate Chapel. His grandfather, Robert Milnes, built a large fashionable town house on Westgate around 1720, and he too lies in the catacombs.

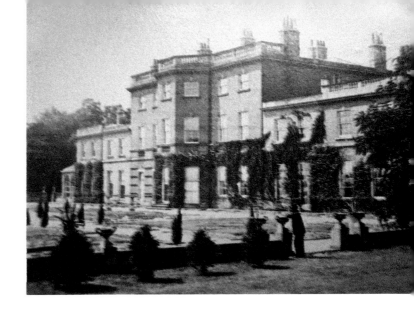

Thornes House was
built in 1779–81 by
the great architect
John Carr.

# Milnes, Mary Bridget

Daughter of Pemberton Milnes, a wealthy cloth merchant, influential Whig and prominent Unitarian, she married firstly P. A. Hay Drummond and secondly Sir Robert Monkton-Arundell, 4th Viscount Galway (1752–1810). Viscount Galway was elected Member of Parliament to represent Pontefract from 1780 to 1783, made a Privy Counsellor in 1784 and knighted in 1786. He was MP for York from 1783 to 1790, and again for Pontefract from 1796 to 1802. His career also included service as Comptroller of the Household (1784–87) during the reign of George III.

Mary remained in Wakefield after the death of her husband. Her daughter married Robert Pemberton Milnes (1784–1858), the son of Richard Slater Milnes and MP for Pontefract 1807–18. She died in 1835 aged eighty-two and lies buried beneath Westgate Chapel with her father, mother and cousins Richard Slater Milnes MP, James Milnes, John Milnes Jr and many other members of the family.

# Milnes, Richard Slater

Heir to Robert Milnes, a wealthy cloth merchant, Justice of the Peace and leading Unitarian, Richard Slater Milnes was born in December 1759. He retained an interest in the wool trade while transforming himself into a country gentleman, residing at Fryston Hall. In 1784 he announced his conversion to Pitt and the Tory party, severing his family's connection with the Rockingham Whigs and associating himself with Christopher Wyvill and the rump of the Yorkshire Association. He supported Pitt throughout his first Parliament. In 1789, when his Pittite colleague and cousin through marriage Lord Galway resolved not to stand again for election as MP for York, Richard Milnes came to secret terms for a compromise with the York Whigs, led by

Earl Fitzwilliam, which secured his unopposed election in 1790 as MP for York. Milnes's re-election in 1796 was again unopposed. He retired as MP for York due to failing health in 1802, claiming never to have given a vote in Parliament 'but from the conviction of his mind, that it was right'. He died on 2 June 1804 aged just forty-four. He is interred beneath Westgate Chapel. His son, Robert Pemberton Milnes, was MP for Pontefract.

# Moot Hall

In the Middle Ages, governance of the town was vested with the steward of the lord of the manor. In terms of legal governance, the manor court was held in the Moot Hall – *moot* being an Old English word meaning an assembly. This building stood close to the parish church on Kirkgate in Manor House Yard, along with the Rolls Office. There was little furniture other than a rough table and a bench, which were for the lord's officers. Everyone else had to stand. The steward of the Earl of Warrenne presided over the court. There was also a criminal court known as the Tourn.

The Wakefield Manorial Court travelled on circuit twice a year, usually in May and October. From 1274 it sat at the Moot Hall in Halifax while dealing with cases relating to the Upper Calder Valley. The court baron was held every three weeks at Sandal Castle, where the court leet was also held twice a year. The court appointed constables, made by-laws and heard cases of minor crime such as burglary or assault. The Moot Hall in Wakefield replaced the administrative function of Sandal Castle during the reign of Henry VIII. Unlike most lords of the manor, the earls of Warrenne held the right to carry out summary trial and the execution of thieves caught in the bailiwick of Sowerbyshire. The gibbet, which was an early instrument for decapitation and predated the guillotine by some 500 years, was used from 1286 until 1650.

The king only granted the privilege of holding such a court to a few of his subjects. The Warrennes received this power, along with the grant of the manor as it had formerly belonged to Edward the Confessor. The site of the Moot Hall in Wakefield is now occupied by Boots.

Exterior of the Moot Hall, which dates from 1656, on Westgate.

# N

## Naylor House

This house was built by wealthy cloth merchant Ebenezer Naylor in the 1720s. The Naylors were leading cloth merchants in the city, trading primarily with government contractors to clothe the army, as well as to Portugal and America. The Naylor family were stalwart Unitarians and had been associated with the first Westgate Chapel of 1697 until the family left the city in the 1830s.

Naylor House was built by Ebenezer Naylor in the 1720s.

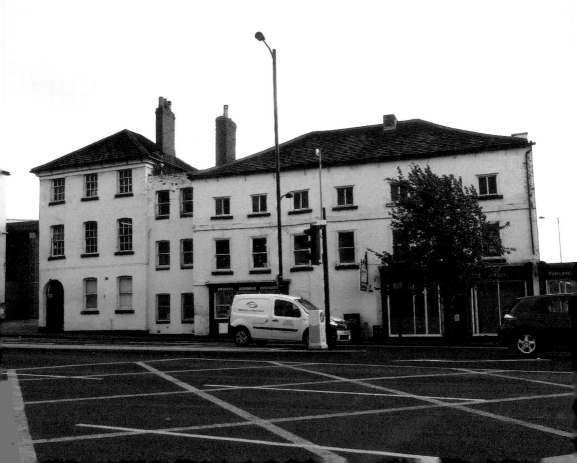

# Navigation Yard

The head offices of the Aire and Calder Navigation in Navigation Yard were built in brick between 1702 and 1704 – it is one of the oldest brick buildings that remains in the city. The adjacent early nineteenth-century stone building was the boardroom. Administration was transferred to Leeds in 1851, and later William Teall took occupation of the buildings, which he used as a grease recovery plant – the area became known as 'Grease 'Ole Yard'.

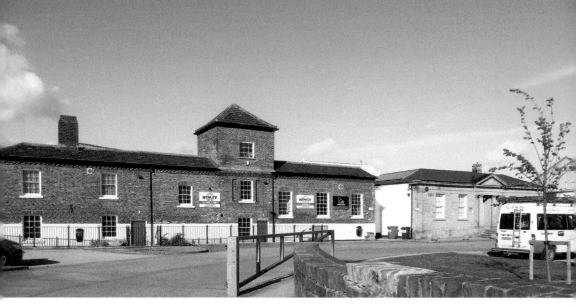

Navigation Yard houses the warehouses and offices of the Aire & Calder Navigation Company. The neoclassical building was the boardroom.

# O

## Orangery

On the northern side of Back Lane is the Orangery, built in an eighteenth-century style as a garden house for nearby Pemberton House. The Orangery was completed around 1760. It was later opened as horticultural and zoological gardens in 1839. A bear kept in the grounds escaped and unfortunately mauled the keeper's wife to death. Later it became a Sunday school for Westgate Chapel and part of the grounds were used as a graveyard. Prominent in the gardens is the monument to the Chartist Joseph Horner, which takes the form of a broken column. At various times it was let on weekdays as a school, the last being the Collegiate School from the 1930s to 1957. Westgate Chapel sold the building in 1991 and it became home to an arts-based organisation. The building is now empty and the city council is seeking to redevelop the cemetery as a building plot, which will sadly entail the removal of many burials – such is the price of progress that these deceased Unitarians cannot rest in peace.

The Orangery on Back Lane (formerly in the garden of Pemberton House) was built in the late eighteenth century.

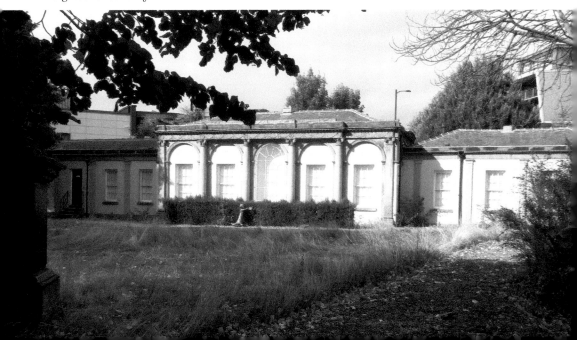

# Pemberton House

Pemberton House, which stands at the entrance to Westgate station, is one of the many fine and large Georgian houses that lined both sides of Westgate. It is a reminder of the many successful merchants that prospered in Wakefield during the eighteenth century. An American visitor in 1777 stated, 'Westgate Street has the most noble appearance I ever saw out of London.' Pemberton House was built around 1752 for Pemberton Milnes. The Milnes family were successful cloth and wine merchants and various branches of the family owned houses on Westgate. Pemberton Milnes became a magistrate and a deputy lieutenant of Yorkshire. In politics Milnes was a Whig, and in religion a dissenter, supporting the Westgate Chapel where he was eventually buried in the vaults underneath the building. These were among the first public burial vaults in the country and helped defray the cost of building Westgate Chapel. Between 1842 and 1864 the house was owned by another prominent Wakefield resident, Henry Clarkson, the author of *Memories of Merrie Wakefield*, which was published in 1887. Pemberton House was taken by compulsory order for the West Riding and Grimsby Railway and was owned by the railway for many years. From around 1872 the house was the

Pemberton House was built *c.* 1752 for Pemberton Milnes, prominent Unitarian, cloth merchant and Deputy Lord Lieutenant for the West Riding.

premises for a Wakefield weekly newspaper, *The Wakefield and West Riding Herald*, which ceased production around 1910. In later years it became the Labour Exchange.

# Potter, John

The late eighteenth-century Black Rock public house stands on the site of the house where John Potter lived as a child. He was to be Archbishop of Canterbury from January 1737 until his death in 1747. He was the son of a Wakefield linen draper. At the age of fourteen he entered University College, Oxford, and in 1693 he published notes on Plutarch's *De audiendis poetis* and Basil's *Oratio ad juvenes*. In 1694 he was elected fellow of Lincoln College, Oxford, and in 1697 his edition of *Lycophron* appeared. It was followed by his *Archaeologia graeca* (two volumes, 1697–98), the popularity of which endured until the advent of Dr William Smith's dictionaries. A reprint of his *Lycophron* in 1702 was dedicated to Graevius, and the *Antiquities* was afterwards published in Latin in the *Thesaurus of Gronovius*.

In addition to other sources of income, in 1704 Potter became chaplain to Archbishop Tenison, and shortly afterwards was made chaplain in ordinary to Queen Anne. From 1708 he was Regius Professor of Divinity and canon of Christ Church, Oxford; and from 1715 he was Bishop of Oxford. In 1707 he published *A Discourse on Church Government*, and he took a prominent part in the controversy with Benjamin Hoadly,

The Black Rock public house, where John Potter, Archbishop of Canterbury, was born.

Bishop of Bangor. It was Potter who ordained John Wesley a deacon in the Church of England in September 1725, and a few years, in 1728, later ordained him a priest.

In January 1737 Potter was unexpectedly appointed to succeed William Wake in the see of Canterbury. He married Elizabeth Venner, granddaughter of Thomas Venner who had been hanged as a traitor. Potter died on 10 October 1747. His *Theological Works*, consisting of sermons, charges, divinity lectures and 'A Discourse on Church Government', were published in three volumes. Published in 1753, Potter's *A System of Practical Mathematics* is a comprehensive reference work addressing aspects of astronomy and the recently adopted Gregorian calendrical system among other topics. He was buried in Croydon Minster in Surrey.

# Public Library and Assembly Rooms

Best known as Wakefield Museum, the building was designed to supplement the Assembly Rooms in Crown Court as a venue for social gatherings, as well as provide space for a public library. The library had been founded in 1786 largely by attendees of Westgate Chapel. Indeed, over 100 subscribers contributed to a new 'Public Library, News Room and Other Public Rooms', buying shares at £25 each. The building opened in 1823 with a series of concerts and was the home of many cultural activities in Wakefield. In 1855 the Mechanics' Institute, in which Revd Cameron of Westgate Chapel was a principal instigator, purchased the building largely due to Daniel Gaskell, the 'uncanonised saint of Wakefield'. The Mechanics' Institute had been using the building since 1842 and it was only in 1935 that it was sold to Wakefield Corporation, becoming the town's museum in 1955. In 2012 the museum moved to the new Wakefield One building. Today the building is part of Wakefield College.

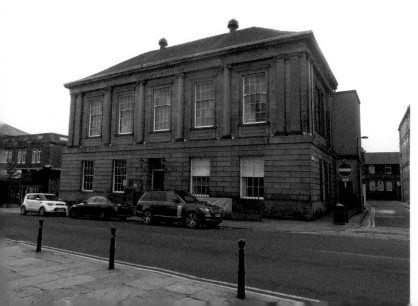

The public library and Assembly Rooms on Wood Street – now part of Wakefield College.

## Quaker Chapel

The first meeting of the Wakefield Quakers was held on Sunday 27 January 1716. Meetings had been held at Quaker House in Agbrigg on Doncaster Road. A plot of land nearby was registered by the quarter sessions in January 1694–95 as a burial ground for Quakers. The small graveyard can still be seen on Doncaster Road. Quaker House still stands opposite the present Wakefield Cemetery, bearing a stone with the date '1772'. In 1805, the former Wesleyan Chapel on Thornhill Street, which had been opened by Charles Wesley in 1772, was sold to the Society of Friends for £500, who proceeded to take out the pews and galleries and adapt the building for their requirements. Twenty years later they were able to purchase a plot of adjoining land, at 10s 6d for the use as a burial ground.

Many well-known Wakefield families have been connected with the Society of Friends: Lumb, Aldam, Leatham, Bonington, Holdsworth, Kitching, Spence, Binks and Wallis. John Bright married Margaret Leatham, sister of Edward Aldam Leatham and William Henry Leatham at the Friends Meeting House in Thornhill Street on 10 July 1847. The old building of 1772 did service for nearly 200 years. It was demolished to make way for the current meeting house in the late 1960s, sadly robbing Wakefield of a building of significant history.

The Quaker Chapel on Thornhill Street.

# Quebec Street Tabernacle

In 1822 a difference of opinion over theology – Arminism as opposed to Calvinism – in the congregation at Salem Independent Chapel on George Street resulted in the congregation splitting, with half establishing themselves as an independent church body under the leadership of Revd Dr Cope LLD.

That same year the small society purchased a plot of land in Quebec Street and employed Mr John Stead as architect of their new chapel. It was a brick building, approximately 14 square yards, and was fitted with pews and a gallery to seat 1,000 people. The building cost £1,000 to build and was opened on 30 November 1823 by Revd J. Farrar of Halifax at 10.30 a.m. The congregation left the building in 1836 as it was proving too costly to maintain and a new much smaller chapel was opened on Queen Street in 1838. By the time of the opening, the congregation had declared themselves to be Primitive Methodists. Ebenezer Methodist Church, as it became, was enlarged in the 1880s and closed in 1954. It became Wakefield Little Theatre and is now semi-derelict.

The Quebec Street Chapel found a new use very quickly after the Primitive Methodists vacated it. It was opened as Wakefield Baptist Chapel on 24 April 1836, with the first minister, Mr Joseph Harvey, being appointed in May 1837. The first

*Below left*: The Former Baptist Chapel on Fairground Road.

*Below right*: The Former Primitive Methodist Church on Queen Street. The congregation that built the chapel formerly met in a much larger chapel on Quebec Street.

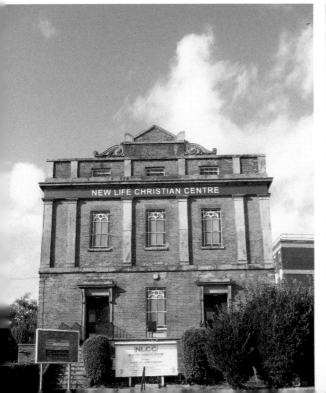
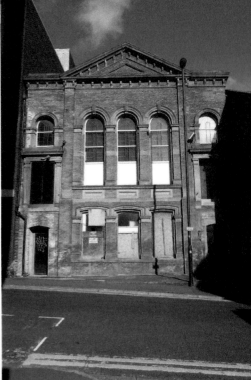

baptismal service was held at Ossett on 9 January 1838 (there being no baptistery in the old Independent Chapel). On 1 February 1838 the eight people who were baptised, together with six others who were or who had been members of Baptist churches in other towns, agreed to unite. It was the formation of this church of fourteen people that led to the establishment of the Baptist denomination in Wakefield. The members increased to twenty-seven and the church was formally constituted on 15 March 1839, and three deacons were appointed. Mr Fox remained for four and a half years, adding seventy-three members to the church. The necessity of a new, much smaller chapel being imperative, land was secured and the present chapel opened on 20 March.

The first stone of the present building in Fair Ground Road was laid on 24 July 1843 by Revd Peter Scott, pastor of the Baptist Church, Shipley. The church at this time numbered ninety-nine members. The new chapel was opened on Wednesday 20 March 1844. At the public breakfast next morning at West Parade Schoolroom, the sum of £200 was promised towards the cost. Quebec Street Tabernacle, however, remained standing but vacant; for a time it became a synagogue and some of the interior was moved in 1866 to Flanshaw Congregational Chapel.

# Queen Elizabeth Grammar School (QEGS)

Queen Elizabeth Grammar School was founded by royal charter of Elizabeth I in 1591 at the request of leading citizens. The original Elizabethan building still exists on Brook Street close to the new Trinity Walk Shopping Centre. In 1854, the school moved to its present site in Northgate into premises built for the West Riding Proprietary School in 1833–34, designed by the architect Richard Lane.

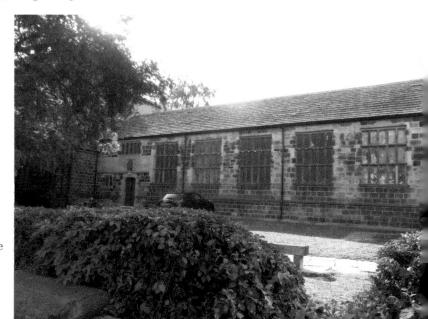

Queen Elizabeth Grammar School buildings on Brooke Street.

# Racecourse

The first evidence of racing at Wakefield was in 1678 on the third Wednesday in August. It took place on the Ings near to Law Hill. However, once gentlemen landowners laid claim to the Ings the racecourse was relocated to Outwood, a course of around 2 miles round. It became established and a grandstand was built from subscriptions by supporters, who were given life membership badges; however, racing only lasted until 1794. The grandstand was designed by John Carr, who was working for the affluent Milnes family in the construction of Thornes House and Westgate Chapel. Although better known for grand houses for the nobility of the period, during his lifetime Carr designed several grandstands, including the one at York racecourse (since replaced) whose design is believed to have been based upon that at Wakefield. There was a lull in organised meetings until 1847 when the Wakefield Grand National was launched by the Earl of Strathmore. It was contested over a 4-mile course consisting of fifty-three fences, starting at Sandal Castle, but lasted for just two years. The final meeting was on Wednesday 21 February 1849.

Wakefield Racecourse Grandstand, *c.* 1780.

# Ridings, The

Following slum clearances that took place in the city centre, a huge redevelopment of the heart of medieval Wakefield took place in the late 1970s. The year 1983 witnessed the opening of The Ridings Shopping Centre, a very ambitious step for Wakefield at the time. Today this provides a landmark retail experience in the heart of Wakefield.

# Rideal, Titus

In addition to local production of broad cloths and the finishing of cloth, there was a strong manufacturing presence of worsted fabrics in Wakefield – at the time called 'tammies'. Titus Rideal was a leading tammy merchant and instrumental in the establishment of the Tammy Hall in 1777. The hall was opened on 10 July 1778 for the sale of tammies, blankets and white cloths. Titus Rideal died 15 January 1790 aged sixty-three. He was neighbour to Dr Amory on Westgate. He was, like his children and grandchildren, a lifelong Unitarian. The Tammy Hall closed in the 1820s and became a worsted mill. In the 1870s it was partly demolished to make way for the Town Hall.

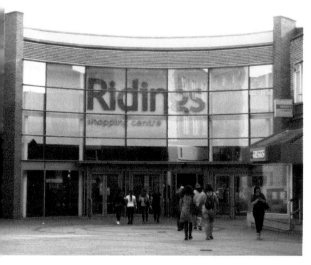

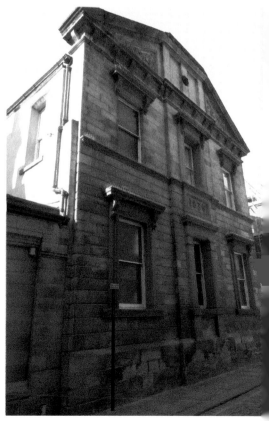

*Above*: The Ridings Shopping Centre.

*Right*: Tammy Hall, built in 1777, still partly stands. Titus Rideal was one of the merchants who had the building built.

# St Austin's Roman Catholic Church

The church on Wentworth Terrace has strong associations with Charles Waterton of Walton Hall, who was among its first benefactors. Built in 1827 by William Puckrin, it was originally a plain structure but was extended and altered in 1852, and later in 1878–79 by the architect Joseph Hansom. The most noticeable feature from the later alteration is the domed Lady chapel.

Saint Austin's Roman Catholic Church.

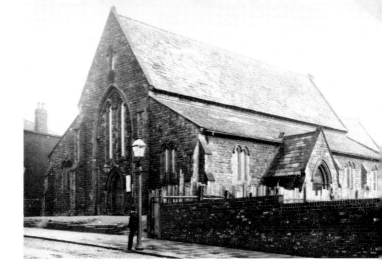

St Andrew's Parish Church on Peterson Road as it was *c.* 1880.

# St Andrew's Parish Church

This church was built in 1846 by George Gilbert Scott (1811–78). Scott was the most successful church architect of his day, although he was also awarded important secular commissions such as the Albert Memorial and Midland Grand Hotel at St Pancras, both in London. St Andrew's represents an early work of relatively modest scale. The interior was significantly altered in the 1970s to the designs of Richard Shepley. Very little of the 1840s interior remains.

# St Faith's Chapel

Opened in 1861 to provide a peaceful retreat for patients at Stanley Royd Hospital, the chapel of St Faith is one of the more unusual churches dedicated to the patron saint. The building itself was identical to St James's Church, Doncaster – the architect of both schemes being George Gilbert Scott (1811–78).

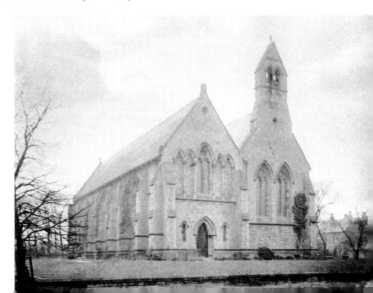

St Faith's Chapel, *c.* 1880.

The chapel was divided into a male patients and female patients by twin naves separated by arches that acted as a divider. The organ was at the end of one nave and at the other the stained-glass window picturing members of various hospital professions with patients, which was added in 1961 to celebrate the work at the hospital. A patient's painting of the Last Supper also hung in the chapel.

St Faith's closed in 1996 after over 130 years. This once magnificent building, which was the heart of the asylum, was left derelict and was gutted by fire on 18 June 2012, only a week after it was sold to a developer who planned to convert the chapel into housing.

# St John's Parish Church

The foundation stone of the first new post-Reformation Anglican church in Wakefield was laid in November 1791, and the church was consecrated in 1795. It had been proposed to build a new church in the early years of the same century but nothing came of the scheme. Built with stone from quarries at Newmillerdam, the cost of the building was partly covered by subscriptions to the building fund, the sale of the right to sit in the church for services (known as pew rent) and the right for internment in the burial vaults below the church. Despite this, the debt was not cleared on the building until 1814. In 1880 the tower was struck by lightning and had to be rebuilt. During a Victorian restoration, galleries were removed and doorways and windows were blocked. The original apse was replaced with a rectangular chancel in 1904 – the same time the current nave arcading was built. The interior has been modernised several times after the 1904 work, the most recent seeing an enlargement of function rooms, as well as kitchen and toilet provision.

*Below left*: St John's Parish Church, *c.* 1880.

*Below right*: St John's Church today.

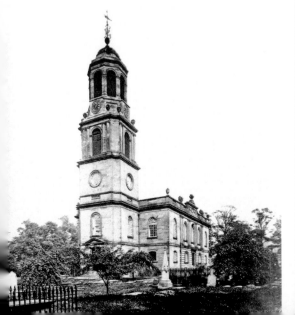
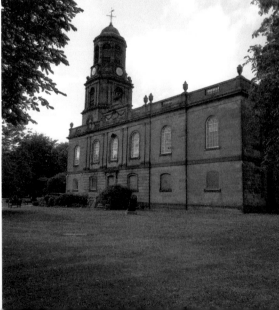

# St John's Square

This Georgian development, promoted by John Lee, a Wakefield solicitor, was completed soon after 1800, with a uniform frontage design but irregular backs. Some were built as shells – just walls, roofs and floors – with interior dividing walls added later.

# St John's North

The house at the eastern end of the area, along with seven other houses, was erected by a building society called the Union Society, led by local builder John Puckrin. Like St John's Square, they were all constructed with a uniform frontage by John Thompson, an eminent architect. This has survived almost intact, apart from an altered doorway and the addition of an oriel window.

# St Mary's Parish Church

The parish of St Mary's was created to cater for the increasing working-class population that was growing up near Kirkgate station, which had been previously been catered for by the parish church and nearby Methodist chapels. Built on Primrose Hill, close by Kirkgate

St John's North with its magnificent Georgian façade (though damaged in a number of places).

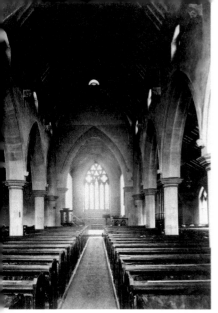

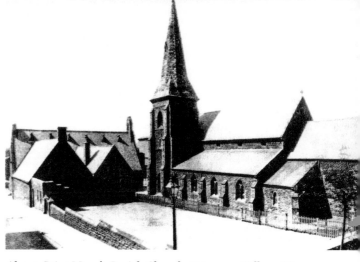

*Above*: Saint Mary's Parish Church, Primrose Hill, *c.* 1880.

*Left*: Interior of Saint Mary's Parish Church, *c.* 1880.

station, it opened on 29 August 1854 and became a parish church on 15 February 1855. The church stood at the upper end of Charles Street. Slum clearances of the 1950s resulted in a depopulation of the area. The church celebrated its centenary in 1954 and was described as 'standing alone amidst piles of rubble and ragwort'. It was closed in 1966.

# St Michael's Parish Church

The foundation stones of the church were laid on 16 April 1857. The church was built to a design of William Dykes of York and was opened on Wednesday 29 September 1858 but was not consecrated until 27 May 1861.

St Michael's Parish Church, *c.* 1880.

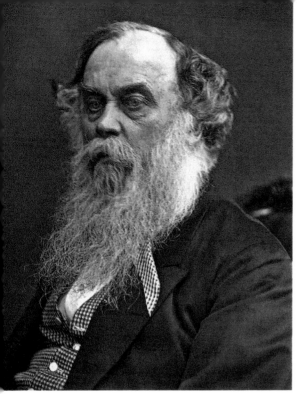 

*Above left*: Titus Salt was apprenticed in Wakefield to Joseph Jackson. He went on to build Saltaire, near Bradford.

*Above right*: This four-floor warehouse was built for Joseph Jackson on King Street in 1811. He ran one of the largest wool-stapling concerns in the West Riding.

# Salt, Titus

Sir Titus Salt (20 September 1803 – 29 December 1876), 1st Baronet, born in Morley near Leeds, was a manufacturer, politician and philanthropist in Bradford. He is best known for building Salt's Mill, a large textile mill, together with the attached village of Saltaire. He has strong Wakefield connections. Salt was educated in Wakefield by Enoch Harrison and after completing his education he worked for two years as a wool-stapler in Wakefield for Joseph Jackson.

# Six Chimneys

Perhaps the best known of Wakefield's lost buildings was Six Chimneys. It stood on Kirkgate and was a fine sixteenth-century timber-framed house – it dates either in part or totality from 1566. Here we see it around 1880. The Six Chimneys stood at the junction of Kirkgate and Leigh Street and below we see Leigh Street stretching away to the right of the image. It collapsed during the Second World War.

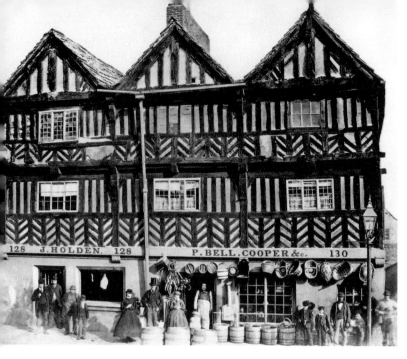

Six Chimneys, *c.* 1880.

# Slavery

One of the great issues of the early nineteenth century was slavery and the salve trade. In Wakefield three men/families owned over 100,000 slaves between them – Arthur Heywood, Francis Ingham and the Waterton family. The Waterton family, owners of Walton Hall, were notorious in the trade, having large sugar plantations in Barbados and owning over 10,000 slaves. Walton Hall, now a fashionable wedding venue, was built on the back of slavery. Francis Ingram, founder of Wakefield's first bank (Bank House on Westgatge), financed this venture through slavery. Between 1784 and 1794

Bank House on Westgate, built by slave master Francis Ingram.

he embarked on 122 slaving voyages and sold over 41,000 people into slavery. The bank closed on 14 July 1814 after being in fiscal difficulties from 1808. The property was later taken over by the Wakefield & Barnsley Union Bank (established in 1832). The building is today sadly neglected. It sports a blue plaque commemorating the bank that built the premises, but there is not one mention of the slave trade upon it.

While some Wakefield men made a fortune from slavery, other Wakefield men were against slavery and endeavoured to abolish it. Sometime Wakefield resident Thomas Day, who attended Westgate Chapel, is considered to be the founding father of the movement to abolish slavery. James Milnes MP and Richard Slater Rich MP, both Unitarians attending Westgate Chapel, supported William Wilberforce in his drive to abolish the slave trade. Thomas Clarkson, Wilberforce's right-hand man, was related to the Clarkson family of Westgate Chapel. Wilberforce visited James Milnes at Thornes House in the 1790s.

# Strafford Arms Public House

The Strafford Arms Hotel, named about the lord of the manor, was once the principle posting house in the town. The building we see was constructed from March 1723. It replaced an inn called the Black Swan, which was demolished that year for being in a state of dilapidation. The landowner was the Earl of Strafford and the new business was known as the Strafford Arms. The building was completed in 1728 and cost the then large sum of £800 1s 6d to construct. The premises were enlarged by four rooms

The Strafford Arms Hotel as it was once in the 1880s.

in 1784 that were rendered externally, and additional stabling was built for the sum of £300. Behind the principle range of buildings was a long yard, entered by an arch from the Bull Ring, in which stood long ranges of stables for the exchange of horses on the end of the stage of the journey from Leeds to Wakefield or vice versa. Numerous stagecoaches ran from here in the late eighteenth and early nineteenth centuries, such as *The Royal Mail* to London, which left Wakefield at 10 p.m. *The Telegraph* left for Birmingham at 6 a.m. and only had four inside seats; the other passengers were conveyed on seats on the top of the coach. It arrived at Birmingham at 8.30 p.m. having travelled via Sheffield and Derby. On the same day were sixteen other departures for places throughout the north of England: *The Union* ran to Barnsley and Sheffield, *The Ebor* ran to York and *The Harkforward* ran to Dewsbury, Mirfield, Brighouse and Elland. Other stagecoaches ran to Hull, Doncaster and Sheffield. The Strafford Arms also offered rooms for travellers and provided dining rooms for many of the social functions held in Wakefield during the eighteenth and nineteenth centuries. The Strafford Arms was demolished to make way for more utilitarian buildings that occupy the site, one of which is named the Strafford Arms and is a public house.

# South Parade

Begun in 1786, South Parade was a Georgian new town development to the south of the city. It was originally financed by the Charnock family, who were colliers and cloth merchants selling woollen goods to the Dutch East India Company. By 1810, the financing of the scheme was partly taken over by the Tootal family. Even so, the scheme to build a square like at St John's came to nought, with the failure of a Wakefield bank in 1812 and again in 1826. This left a large gap between Nos 4 and 5 South Parade and just two buildings of West Parade were ever built. The centrepiece of the scheme was the handsome West Parade Chapel – now demolished.

South Parade was Wakefield's second Georgian development, financed by the Charnock family. By 1830 the street was home to most of the leading Unitarian families of the town: the Tootals, Robesons, two branches of the Burrells and the Marriotts.

# T

## Taylor, Kate

Kate was one of three daughters of George Taylor, a manager for the national grid, and his wife Dora. She won prizes at the local girls' high school and went on to study English at St Anne's College, Oxford. During her vacations she worked as a freelance contributor for the *Yorkshire Post*, interviewing Kingsley Amis, Iris Murdoch and John Braine. She graduated from Oxford but pregnancy forced her home due to being 'irretrievably alienated from the baby's father', as she put it. Defying parental and social pressures, she struggled through the 1960s and 1970s as a single parent. She became a teacher, first in secondary schools and then at teacher training colleges in Leeds and Barnsley. In 1978 she became vice principal at the new Barnsley Sixth Form College. She later worked for the Open University, lecturing to inmates in the high-security HMP Wakefield. She was an effective teacher, but journalism constantly beckoned.

During European Architectural Heritage Year (1975), Kate was press officer for Wakefield Heritage Committee, formed to organise local celebrations, for which she wrote a series of articles on church buildings. Nationally, she worked for the Unitarians as a press officer and was a frequent contributor to their newspaper, the *Inquirer*. She was a member of the Unitarians' penal affairs panel, working to improve prison education and issues affecting women in prison.

Kate worked as an author and editor on many publications about Wakefield, including *More Foul Deeds* and *Suspicious Deaths in Wakefield* (2003), *The Making of Wakefield* (2008), and two volumes of *Wakefield District Heritage*. In 2005 her frank autobiography, *Not So Merry Wakefield*, was published. As a result of her final book, *Wakefield Diocese: Celebrating 125 Years* (2012), she was made a lay canon of Wakefield Cathedral.

As chairperson, secretary treasurer and fundraiser for Friends of the Chantry on Wakefield Bridge, she produced a booklet telling its story. She was president of the Wakefield Historical Society and became editor of its journal, supporting campaigns to retain significant buildings. She was president of Wakefield Civic Society and a member of the group of Wakefield Historical Publications and of the Gissing Trust, which runs a small museum.

After her funeral, held at Westgate Chapel, it emerged that Kate's name had appeared in the Queen's birthday honours list for 2015, with an appointment as MBE for services to heritage and to the community in Wakefield. The honour was received on her behalf by her son Simon, who survives her along with a sister, Enid, and a grandson, Barnaby. From the 1970s she was an ardent Unitarian and supporter of Westgate Chapel.

# Town Hall

In 1848 Wakefield became a Borough and gained the right to have an elected mayor and the Town Hall was set up in Crown Court. In Crown Court, the building displaying "Town Hall" on its façade had originally been built as new Assembly Rooms, opening about 1801. In later years it became a Chapel for the Methodist New Connexion, opening as such on 24 March 1822. The Chapel moved to new premises in 1861 when the premises became the Town Hall. Once the current Town Hall was built, the building became an Organ Building Factory for the firm of Alfred Kirkland, which had branches in Wakefield. Nottingham, and London. The site between the Courthouse and the Music Saloon on Wood Street (formerly the City Museum, now premises for Wakefield College) was purchased by Wakefield Corporation in 1854, but it was not until 1877 that the building work commenced on a new town hall. The building was designed by T. W Colcutt, a London architect, in a French Renaissance style. The foundation stone was laid by the Mayor, Alderman W. H. Gill, solicitor, in October 1877, and the building was opened in October 1880 by the Mayor, W. H. Lee, whose names are commemorated by Gill Street and Lee Street which adjoin the building.

The Town Hall, completed in 1861.

The Towers, Bond Street, a landmark set of houses designed by William Crutchley, a notable Unitarian architect.

# Towers, The

Standing on Bond Street is one of Wakefield's most distinctive row of terraced houses. These ample and elegant villas were designed by William Crutchley (1829–1905) and completed in 1880. Crutchley was an architect, engineer and surveyor. Other buildings of his include King Street Chambers, which was completed in 1878. For a time, he was an active member of Westgate Chapel.

# Trinity Walk

As part of the redevelopment of the former Wakefield Gasworks complex a new shopping mall was planned and work began in 2008. The scheme was on the verge of failure in March 2009, but the idea was resurrected in 2010 and the mall finally opened on 6 May 2011. Wakefield Council describe it as 'the most important City Centre development for more than 20 years'.

Trinity Walk shopping mall.

# Unitarian

Unitarianism marked its 450th anniversary in January 2018. Unitarianism is a liberal Judaeo-Christian faith. It is an open-minded and individualistic approach to religion that gives scope for a very wide range of beliefs and doubts. Religious freedom for each individual is at the heart of Unitarianism. Everyone is free to search for meaning in life in a responsible way and to reach their own conclusions.

The roots of the Unitarian movement lie mainly in the Reformation of the sixteenth century. At that time people in many countries across Europe began to claim the right to read and interpret the Bible for themselves, to have a direct relationship with God without the mediation of priest or church, and to set their own conscience against the claims of religious institutions. The earliest organised Unitarian movements were founded in sixteenth-century Poland and Transylvania. In Britain, Unitarianism was damned as heresy and the death penalty was imposed on anyone who denied the Trinity. With Unitarianism seen as heresy and specifically forbidden by Parliament's Toleration Act of 1689, several early radical reformers who professed Unitarian beliefs in the sixteenth and seventeenth centuries suffered imprisonment and martyrdom.

The Unitarian approach to looking at God as one became more widespread in the Church of England in the seventeenth century. John Biddle, a Gloucester schoolmaster, often called the father of English Unitarianism, wrote and spoke extensively on his views; he died in prison in 1662. Samuel Clarke, rector of St James's, Piccadilly, came under severe censure when his book *The Scripture Doctrine of the Trinity* (1712) argued that supreme honour should be given only to God, the Father.

The term applied to Unitarians at this time was 'rational dissenters'. Theophilus Lindsey, Vicar of Catterick, Yorkshire, left the Church of England to found the first avowed Unitarian church in Essex Street, near the Strand in London, in 1774. The site remains to this day the headquarters of Unitarianism in Britain. Local, if not regional history was made when the first same sex wedding was celebrated in Wakefield and district – same sex weddings being a Unitarian cause for many decades. Today, like our ancestors who built the chapel in 1752, we are liberal religious thinkers who value diversity of belief, respecting insights from numerous religions.

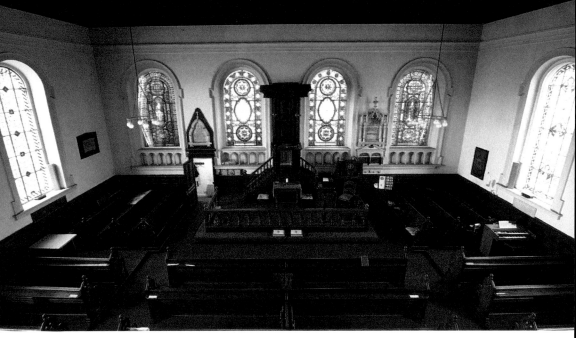

Interior of Westgate Chapel, home to Unitarians in Wakefield since 1752.

# United Methodist Free Church

The movement was started in 1848 with members of the Wesleyan Methodist Connexion who felt dissatisfied with the way the connexion was run and sought reform. Over 1,000 members left West Parade Chapel and met in the Corn Exchange for services. A new United Methodist Free Church was built on Market Street. It was closed in 1935.

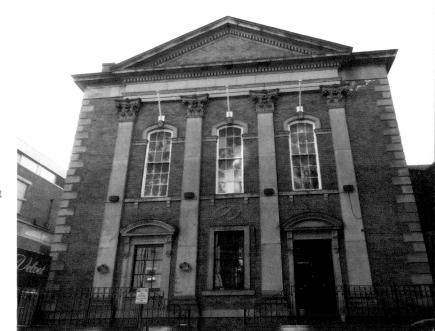

The former United Methodist Free Church on Market Street is a landmark building in the city centre.

# Unity Hall

Unity Hall, built by the Wakefield Co-operative Wholesale Society, opened in 1901. It was an extension to the original Co-operative Society buildings on Bank Street, which dated from the 1870s.

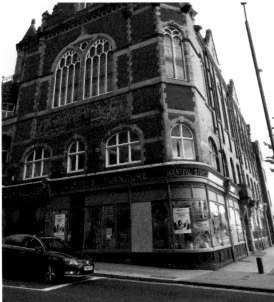

*Above*: The oldest part of Unity Hall dates from 1877 and stands on Bank Street.

*Left*: Unity Hall is a major landmark building in Wakefield.

# V

## Vicarage, Old

Standing on Zetland Street is one of Wakefield's oldest buildings, the old vicarage. It was built sometime between 1666 and 1671 and appears to incorporate parts of an earlier building dating from 1349. In 1852 the building was sequestrated by the West Riding Bank and the contents sold to cover the debts of the then vicar of Wakefield, Revd Samuel Sharp (1773–1855). Following his death, his successor, Revd C. J. Camidge, occupied the old building, and it was not until 1875 that the vicarage was moved to Sandy Walk by the Revd Normal Demunil John Stratton. The old building was purchased by Edward Green and became home of Wakefield Conservative Club. The building was extensively modernised in 1908 for the then vast sum of £1,800. Today the building houses a variety of small businesses.

## Vincent House

Built for James Milnes, a wealth cloth merchant and Unitarian, the house makes a major contribution to the streetscape of Westgate. From 1804 the woollen manufacturing

Vincent House was built in the 1760s by James Milnes.

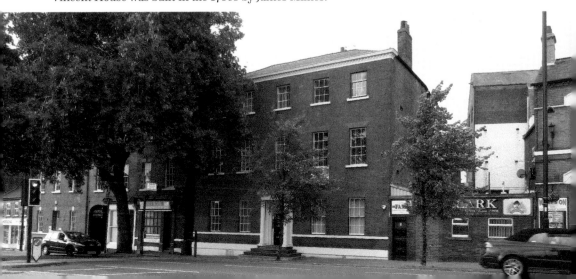

concern of Milnes & Co. behind the house was managed by Rachel Milnes of Fryston Hall, widow of Richard Slater Milnes MP. Her sister Mary Anne had married James Milnes MP. In 1806 Rachel entered into partnership with co-religionists, the Unitarian Holdsworth family, as Milnes & Holdsworth & Co. The partnership was dissolved in 1824 and Rachel Milnes continued to run the company until 1831. This was one of Wakefield's early mechanised mills as a large new steam engine was installed in 1827. Mrs Milnes was a remarkable women, running a major business and overseeing its total mechanisation; her Unitarian faith and the ideals of Westgate Chapel that all are equal regardless of gender, clearly inspired her to challenge the stereotype of what a women was expected to do in the early nineteenth century.

# Victoria, Statue of

The statue of Queen Victoria was unveiled on 15 February 1905. It moved to Thornes Park on 10 July 1950 and was moved back to the Bull in the 1980s, and to Calstrop-Rauxhall Square in 2012.

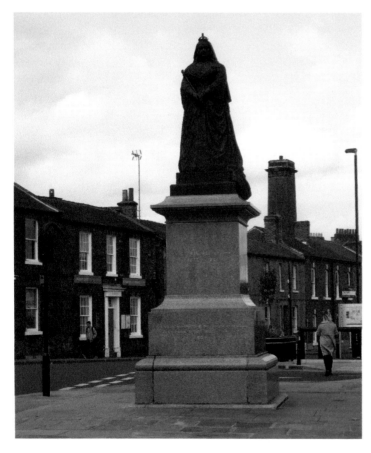

Queen Victoria's statue now stands opposite the County Hall.

V

# Votes for Women

The year 2018 marked the 100th anniversary of votes for women. This was a cause championed by Revd Goodwyn Barmby since 1841, who declared in the name of Mary Wollstonecraft that the People's Charter be amended to include women's suffrage, stating 'If woman is not free, man must ever be a slave.' In Wakefield it was Westgate Chapel and the Barmby family that championed women's rights. The first rally for universal suffrage was held in Wakefield in 1864. Two years later a group of suffragists created a petition to lobby Parliament to give women the vote – a cause was championed by the Barmbys. It was ultimately unsuccessful, but it was the first major effort to gain women the vote. Undeterred, in the following year the Barmbys organised a large demonstration in Wakefield in favour of universal suffrage.

The same year – 1867 – the Manchester Society for Women's Suffrage was formed. The Barmbys were involved in the society from day one. The society's aim to obtain the same rights for women to vote for MPs as those granted to men was formed at a meeting in Manchester in January 1867. The society underwent several name changes as it affiliated with other women's suffrage organisations. It became the Manchester National Society for Women's Suffrage (MNSWS) in November 1867 when it joined London and Edinburgh societies in the National Society for Women's Suffrage. In 1897, with around 500 other suffrage societies, the MNSWS joined the National Union of Women's Suffrage Societies (NUWSS) and changed its name to the North of England Society for Women's Suffrage. In 1911 it became the Manchester Society for Women's Suffrage, part of the Manchester District Federation of the NUWSS. The founder of the Manchester Society was Lydia Becker. An extant letter shows she recruited Revd Barmby to help recruit members and evangelise. He gave her names of other leading lights, notably Anne Knight who lived in France. It is therefore of no surprise that the Barmbys were actively involved from the off with the movement. Barmby, however, seems to have had issues with Richard Pankhurst. In 1868, the Barmbys formed an active Wakefield branch. Miss Julia Barmby was made honorary secretary of the Wakefield Committee of the National Society for Women's Suffrage. Ultimately, the Pankhursts inherited a movement that had been actively supported by Wakefield men and women for decades, and a movement that the Unitarians of Wakefield had helped to create. Women of England owe Revd Goodwyn Barmby and Lydia Becker a debt of gratitude.

# Wakefield and Barnsley Union Bank

The magnificent building was designed by H. F. Lockwood in 1877–78 for the Wakefield and Barnsley Union Bank, which moved here from its more modest premises lower down Westgate at Bank House.

   The Wakefield and Barnsley Union Bank was formed in 1832 in the aftermath of the collapse of a Wakefield-based bank. With the failure in 1825, Wentworth, Chaloner & Rishworth, the Huddersfield banking company, opened an agency in Wakefield. In 1832 the Wakefield Banking Co. was formed, becoming the Wakefield & Barnsley Union Bank in 1840 with the purchase of Beckett & Co. of Barnsley. The bank later merged with Barclays and the building became home to the ill-fated Wakefield Building Society. In the 1970s the shock discovery was made that the present and previous general managers had, over many years, embezzled a fortune. The society merged immediately with the Halifax Building Society. Today the building houses a nightclub.

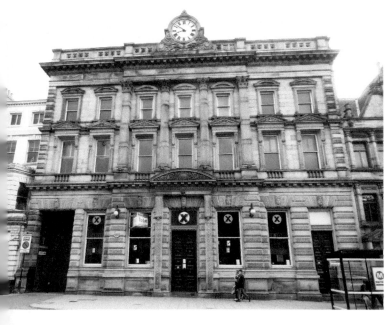

Wakefield and Barnsley Union Bank building is another major landmark in the city centre, although its future is uncertain.

# Westgate Chapel

Westgate Chapel is a hidden by Emerald House, a modern building in stark contrast to the eighteenth-century chapel and Victorian buildings that stand opposite. It was seems to have been erected with little thought to the buildings around it and blocks site lines to the chapel and Orangery behind. The handsome brick-built Westgate Chapel dates from 1752 and is a hidden gem of a building, not only due to its fine interior, but as one of Wakefield's oldest buildings. The façade has hardly changed since 1752 – bar the removal of the clock on the pediment, which occurred sometime before 1880. The magnificent pulpit dates from 1727 and was moved to the current building from the former chapel at Westgate End, which opened in 1692. The chapel interior was altered after the restoration of 1880. The old box pews were replaced with new open-ended pews, and the old pew ends were made into a handsome dado skirting. The fine pulpit was retained but altered to suit the needs of the congregation as it then was.

The chapel of 1752 was built to replace the older one at Westgate End to plans by John Carr. Originally a place of worship for Protestant dissenters in the eighteenth century, the chapel is now Unitarian. The roots of the congregation can be traced from the 1630s and early members suffered some ostracism and persecution. The present chapel was opened in 1752 at a service of dedication to truth, which was led by a known unorthodox speaker. A subscription to light the chapel with gas was started in 1834 and the new gas lighting was installed in 1836 – the first place of worship in the then town to do so. Incidentally, chapel member John Whitaker, to whom a memorial plaque can be found, was the chief officer of the Wakefield Gas Light Company for thirty-two years. The chapel's lighting was, unsurprisingly, installed by this firm. Whitaker was the local Registrar of Marriages for a period of thirty years.

Coke stoves had been installed to heat the chapel in 1791 – presumably services in the winter before must have been uncomfortably cold. Westgate Chapel had its own internal circulating library by 1760, and in 1786 the congregation was represented on the committee that founded the first public library in Wakefield. The Dissenters

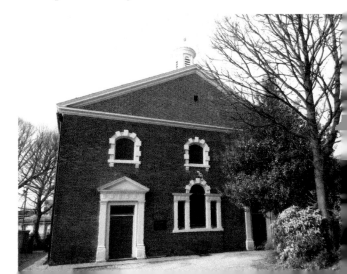

Westgate Chapel dates from 1752. It was the first place of worship built in Wakefield after the Reformation.

Library, supported by Dr Caleb Crowther, John Pemberton Heywood and Thomas Lumb, was founded in 1799, the latter two men being chapel members. In another field, a member of the congregation established the first successful Wakefield newspaper. The paper was run in the Liberal interest and was financially supported by at least one other member of the congregation.

The chapel has a fine organ by the Wakefield organ builder Francis Booth, dating in part from February 1874; it has been restored and repaired. Many noted Wakefield residents are associated with the chapel, including Daniel Gaskell, the first MP for the new Wakefield parliamentary borough in 1832, who was also one of the trustees of the chapel. The congregation still has members active in a wide range of local concerns – religion, politics, the environment, alternative trading patterns, the disadvantaged, regional historical studies and more.

# Westgate Railway Station

In 1857 the line from Wakefield to Leeds was opened and had resulted in a portion of John Milnes' mansion on Westgate being made into the station. An Act was obtained in 1862 by the West Riding & Grimsby Railway for the construction of a line from Doncaster to Wakefield, including a station in Wakefield, which was intended to be placed on The Ings. The line was built but it was felt that the proposed new station would be inconvenient, being 40 feet above surrounding land. New plans were prepared by which it was sought to take the line through the old station on Westgate and build a new one on the north side of Westgate. A viaduct approaching the new station, consisting of ninety-five arches and nearly a mile long, was built and required 8 million bricks. It is known locally as the '99 arches', despite not having ninety-nine arches. An iron bridge was built to cross the Calder. The new Westgate station was opened in 1867 with a 77-foot-high clock tower. With the redevelopment of the railways in the 1950s and 1960s, the railway was modernised, not only in terms of motive power, but also in buildings. A new stark and austere Westgate station arose from the rubble of the old building. This mundane modernist building was demolished in recent years, along with what remained of the fine old grand building, and replaced by a rather uninspiring new station.

The new Westgate station is a far superior building to the stark station of the 1960s.

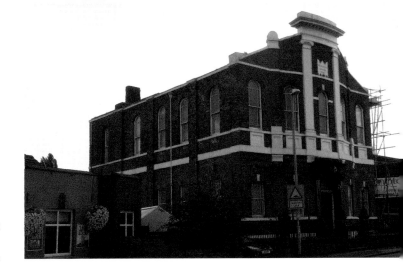

Westgate End Wesleyan Chapel was opened in 1828 and closed in 1993.

# Westgate End Wesleyan Chapel

This chapel opened in 1828 and was closed in 1993. The building was renovated and enlarged in 1886 when a beautiful pitch-pine interior was installed, described by the architectural historian Pevsner 'as a gem'. The interior has been largely removed to adapt the building for different uses.

# West Parade Wesleyan Chapel

Opened in 1802 and built as the centrepiece of the development of West and South Parades. The architect was Charles Watson of Doncaster. It was enlarged in 1838 to seat over 1,200 people. The interior was renovated in 1880 and 1896. The chapel was closed in 1963 and stood derelict for a decade before demolition, robbing Wakefield of one of its finest Georgian places of worship.

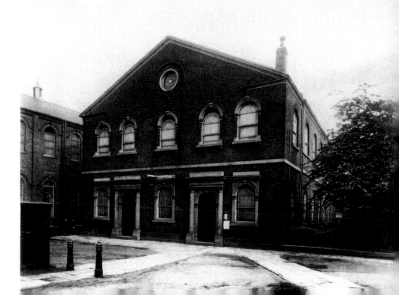

West Parade Chapel as it was, c. 1880.

# X-ray Department

Clayton Hospital on Northgate was opened in 1879 thanks to the generosity of Unitarians, most notably Mr Daniel Gaskell. In 1900, his great-nephew paid for the Milnes Gaskell Wing. The Canning Child Outpatients was the gift of a Wakefield man made good in the USA, in 1932. The following year the X-ray Department was opened – a gift to the city by the Miners Welfare Association. Today, in 2018, the site is to be demolished to make way for an extension to Queen Elizabeth Grammar School. The gift to Wakefield by three generations of Unitarians will be lost for ever. Such is the price of apparent progress.

# Y

## York House

It was James Banks who built Wakefield's first purpose-built theatre in 1776 – the Theatre Royal on Westgate. Mr Banks, who was a wealthy wool merchant, built and resided in York House, which stood on Drury Lane behind the theatre in the 1760s. His father, John Banks, had been a very prosperous wool-stapler. James Banks died in 1814 and his second wife remained in the house until 1830. It was then tenanted to William Naylor, a Unitarian and member of J. & J. Naylor & Co. of Wakefield. The house was sold in 1839 by Joseph Smedley and the proceeds distributed to various cousins of James Banks. William Stewart, a director of the Wakefield and Barnsley Union Bank, was the next owner and gave it the name 'York House'. Following Stewart's death in 1886, the house was empty until it became a gentleman's club in 1893. The Wakefield and County Club came to an end in 1957. Today it is a hotel and restaurant.

The theatre that James Bank constructed was managed by the notable Tate Wilkinson, and many famous actors starred in productions held here, including Mrs Siddons and Edmund Kean. In 1894 the owner of the theatre, Benjamin Sherwood, had a new theatre built on the same site as the previous building to the design of the well-known theatre architect Frank Matcham. Upon opening, the theatre became renamed as the Theatre Royale and Opera House. During the middle years of the twentieth century it was used firstly as a cinema and then as a bingo hall. It was restored as a theatre in the early 1980s, reopening in 1986.

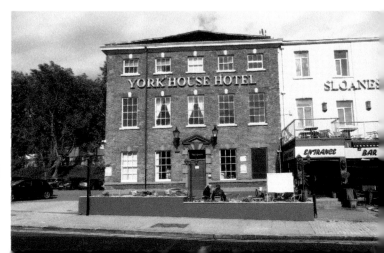

York House dates from the 1760s and was built by wool stapler John Banks.

# Zetland Street

Now the home to an eclectic mixture of shops, the timber-framed Old Vicarage dates back to 1349. It has a fine example of a protruding exterior chimney stack. The Victorian Masonic Hall is a good example of late nineteenth-century architecture. The pediment above the doorway is decorated with Masonic symbols. The first lodge founded in Wakefield was Unanimity, in 1766.

The Masonic Hall on Zetland Street is the only old building to survive on the street.

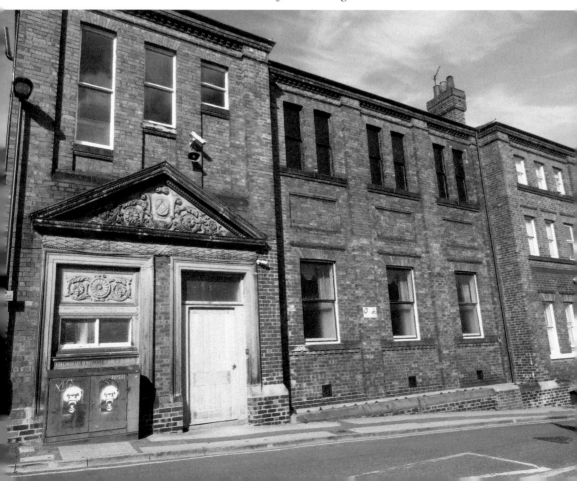

# Zion Chapel

It was not until the last quarter of the eighteenth century that the Independents made any endeavour to form a Congregational church in Wakefield. For some years, however, the Revds Sugden, Gallon and Sutcliffe used to visit the town and preach at the house of John Thompson, next door to the Playhouse in Westgate – John and his nephew Samuel Thompson were the founders of Independency in Wakefield. In 1778 Revd Ralph preached in here and was threatened for preaching in an unlicensed house. On the following Sunday he preached in the house of Thomas Wood at Flanshaw to a large assembly. In 1781, Revd James Wrath of Bolton, then visiting Wakefield, preached during the week at his brother's house.

In 1782 it was decided to make the corn barn at the bottom of the Great Bull Yard a meeting house; Revd William Tapp officiated at the opening.

A plot of land was purchased on 22 October 1782 for the sum of £70, and the erection of Zion Chapel was began. The new building was opened on 1 January 1783 by Rev John Cockin and Thomas Grove, being generally then known as 'Bruce's Chapel'. He remained at Wakefield for forty-four years, but suffered a paralytic stroke in 1826 and died on 1 June 1833, aged seventy-eight.

The foundation stone of the current Zion Chapel was laid on 20 July 1843. William Shaw was responsible for the design and was one of the major benefactors. So too was Caleb Crowther MD. Standing 100 yards or so along George Street directly opposite Holy Trinity Church was Salem Independent Chapel, which was opened in 1801 and closed in 1935. Today Zion Chapel is now apartments.

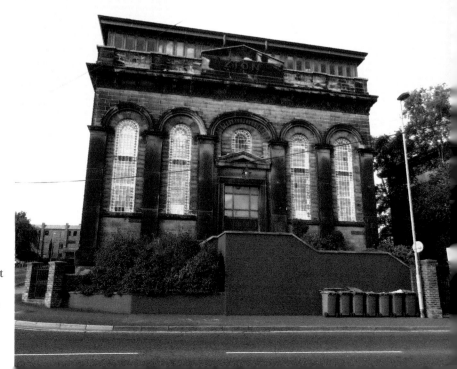

Zion Chapel is now a select residential development.

# Bibliography and Further Reading

Banks, W. S., *Walks About Wakefield* (Wakefield: Wakefield Historical Publications, 1987).

Camidge, C. E., *A History of Wakefield and its Industrial and Fine Art Exhibition* (Wakefield: 1866).

Clarkson, Henry, *Memories of Merry Wakefield* (Wakefield Historical Publications).

Goodchild, John, *Aspects of Medieval Wakefield and its Legacy* (Wakefield Historical Publications).

Goodchild, John, *The Coal Kings of Yorkshire* (Wakefield Historical Publications).

John FSA, James, *History of Worsted Manufacture in England* (London: Longman, Broom, Longmans & Roberts, 1857).

Priestley, Joseph, *Historical Account of the Navigable Rivers, Canals and Railways of Great Britain* (Wakefield: Nicholson, 1831).

Taylor, Kate, *The Making of Wakefield: 1801–1900* (Barnsley: Wharncliffe, 2008).

Taylor, Kate (ed.), *Wakefield and District Heritage*, two volumes (Wakefield EAHY Committee).

Walker, J. W., *Wakefield Its History and Its People*, two volumes (Wakefield: Private, 1936).

Wilson, Richard George, *Gentleman Merchants: The Merchant Community in Leeds, 1700–1830* (Manchester: Manchester University Press, 1971).